PLACEMENT ART

PENELOPE ANNE LINDSAY
WITH LELAND WILLIAMS

PLACEMENT ART
A BEGINNER'S GUIDE TO FENG SHUI

The Way

Tengu Books

New York • Tokyo

First edition, 1998

Published by Tengu Books
568 Broadway, Suite 705
New York, NY 10012

Calligraphy by Mary Jo Maraldo.
Illustrations, book and cover design by D.S. Noble.

Library of Congress Cataloging-in-Publication Data
 Lindsay, Penelope Anne.
 Placement art: a beginner's guide to feng shui / by Penelope
 Anne Lindsay.
 p. cm.
 Includes bibliographical references.
 ISBN 0-8348-0413-1
 1. Feng-shui. I. Title.
 BF1779.F4L572 1998
 133.3'337–dc21 97–51963
 CIP

Contents

Foreword

Thousands of years ago in ancient China the wisdom contained within the pages of this book began its journey to you. At a time before written language, when people began to settle in fertile river valleys and grow crops, it is said that a wise and revered sage and ruler, Fu Hsi, laid the foundation for Chinese cosmology, and in so doing, created feng shui, the art of placement.

In truth, there has always been the need to find safe and secure locations where people can live and prosper. Life literally "takes place," and the ability to select, design, and construct homes and villages so as to be in harmony with the chi—the vital life force—of the land and atmosphere is essential for survival. This ancient art of feng shui is fast becoming part of Western culture due to the simple fact that it works. It's an elegant system for design and arrangement that goes to the heart of what people need in order to feel comfortable and secure in their surroundings, regardless of their cultural background, their economic status, or their beliefs.

We see daily the suffering of the homeless, reduced to wandering in search of shelter in a society prosperous enough to provide for all. Those wealthy enough to afford the most popular and expensive modern architects to design their homes often suffer as well, destined by apparent success to live in homes filled

with complex shapes and angles. Perhaps these impos-
ing structures, filled with the latest man made materi-
als, colors, and decorating styles, may actually be cold
and uncomfortable for their inhabitants.

Feng shui entered my busy life of design and con-
struction at a time when I was searching for a better
way to serve the needs of the clients I designed and
built homes for. After reading the few books available
on it and using what I discovered to solve design
problems with wonderful results, the course of my life
began to shift. Soon people were asking for feng shui
advice, and the quest for a deeper understanding led
me to my master, Professor Thomas Lin Yun. Now I go
wherever called throughout the world, leading work-
shops and giving advice. No matter what the culture
or the language, feng shui brings typically miraculous
results, perhaps the most meaningful of which contin-
ues to be a profound appreciation for the power of
place. There is real simplicity and elegance in the abil-
ity of feng shui to to restore a sense of meaning to our
earthly existence. Through it you may discover how to
alter and improve your destiny by simply, quickly, and
effectively rearranging and enhancing your living or
work environment.

To this end, I'm honored to write this forward for
my friend and fellow student Penelope Anne Lindsay.
In her clearly written and gentle style, you will dis-
cover the source and underlying mechanisms of feng
shui, and why it works. Principles, the how–tos of
diagnosis and solutions, and the ways in which you
can can incorporate this awareness of the intimate
connections between people and spaces into your own
life are grounded in real–world examples. And true to
the all–encompassing nature of this practical and mys-
tical art, she shows you how to have success as you
continue on your journey of understanding. For after
all, while this ancient wisdom has taken thousands of
years to get to your doorstep, it is up to you to bring

it into your life, and the lives of your friends and family, increasing your store of creative gifts and insight, so that all may live in a better world, transforming problems and discomfort into harmony, balance, and prosperity through the power of place.

Seann Xenja
International Placement & Design Resources
Yountville, California
Spring 1998

Preface

Feng shui (pronounced *fung schway*), the Chinese art of placement, evolved from the observation that people are influenced by their surroundings. More than five thousand years ago, perceptive people realized that everything in the environment had an effect. Site orientation, surrounding landforms, plant and animal life in the vicinity, and the shapes, colors, materials, and even thoughts used in building construction were some of the factors recognized for their impact.

Once the ancients understood that their surroundings affected them, they discovered and described the ideal site. This site offered optimal sun, access to water without the danger of floods, and protection from harsh winds. The ideal site supported its inhabitants beyond simple survival; people who lived there grew successful and prosperous. Since the ideal site was not always available, the search for antidotes to the problems encountered with other sites fueled the development of the art of feng shui, which was used to maximize the effect of positive influences and minimize or deflect negative influences.

Feng shui is based on centuries of investigation into the interaction between people and places. Over time, placement art evolved from merely providing antidotes to problems into the art of designing advantageous settings as well. It continues to evolve as it

encounters new cultures and combines perspectives from many arenas, including biology, physiology, geography, ecology, architecture, aesthetics, art, design, folklore, psychology, philosophy, and spirituality.

Feng shui is becoming popular outside Asia because it works. It works for us whether or not we know anything at all about Chinese history and philosophy. The feng shui system is built on a language of energy description and analysis elucidated thousands of years ago and still valid today. Using this system, intuition, and a touch of magic, feng shui practitioners assess the availability, quality, and value of place energy. This process exposes missing or weak areas, which are then arranged and adjusted to improve energy deficiencies. These changes are designed to bring the entire site, home, or office into balance, thereby bringing harmony to the people who live or work there.

The environments we create symbolize our consciousness; they are a mirror of our thoughts and a reflection of our state of mind. Feng shui gives us a simple and easily understood blueprint for balance, a powerful yet practical tool for perceiving and designing a wholesome existence. It brings order and harmony to us through good placement and balance within our surroundings and opens us to experiences of well–being, prosperity, and peace. The peaceful feeling we gain when we balance our spaces radiates out into the world, helping it become a better place.

Everyone benefits when the circle of people who appreciate, understand, and use the art of placement expands. Each of us can benefit by applying feng shui to our surroundings; we are limited only by our awareness and understanding. Halfway through the twentieth century, meditation, a powerful tool for awareness, came to us from Asia. Now, near the end of the century, again from Asia, comes feng shui, an important next step in the journey toward mindful living.

Change and movement are the essence of feng shui. This book may inspire thoughts of moving; in fact an

old feng shui adage warns us not to consult a feng shui practitioner if we aren't ready to move. The idea of moving may literally translate into the ordeal of finding a new residence and relocating. On the other hand, what moves might just be a subtle change in our perspective. In any case, the purpose of this book is to simply and clearly explain a venerable device proven to change and improve life.

Part I of this book first provides an overview of the power of place from both classical and modern perspectives. Next, energy is examined through traditional nomenclature and interpreted in updated terms. The perception of energy is the foundation of feng shui practice. Then, the feng shui blueprint for balance is explained. This explanation includes a brief history of the map itself as well as a description of its application to site, home, room, office, desk, and bed.

Part II presents the factors used in evaluating sites and living spaces, a simple place energy quiz, and common problems of placement. The nine solutions ordinarily employed as cures for problematic areas or as enhancements for areas in need of an energy boost complete this section.

Part III begins with a step–by–step method of harmonizing our work and living spaces to clear the way for experiencing well–being and abundance. Further information regarding feng shui is presented in a question–and–answer format, along with energy-clearing rituals, suggestions for protecting one's personal space and energies, and a practice that assists the development of personal intuition.

Feng shui awareness motivates us to perceive and understand our relationship with our everyday life more clearly. Using this knowledge to arrange balance and genuine well–being for ourselves brings us dignity. As our feng shui insight develops, we accept personal responsibility for uplifting our lives, and as we design a better life for ourselves with placement art, we empower ourselves and enrich our world.

Appreciations

I have been blessed with great teachers. Chögyam Trungpa Rinpoche, Mary Jo Maraldo, Takamatsu Sensei, Jean Erdman, Seann Xenja, and James Allyn Moser are just some of their names. I wish to thank all my teachers; whether or not I have mentioned you here, the role you have played in shaping my life is acknowledged and appreciated.

Credit for this book must go to my feng shui clients, students, and colleagues. I am grateful, too, for the support and assistance of my family, Paul, Charles, and Georgia. And thank you to Ray Furse, David Noble and the talented people at Weatherhill.

For the elegant calligraphy which graces the pages of this book, Mary Jo Maraldo deserves special recognition. Thanks also to Mary Jo, Susan Tydings and Paul Lindsay for reading the manuscript and making constructive editing suggestions.

I am indebted most of all to Leland Williams, my collaborator on this book. The flow and clarity expressed in these pages is largely a result of her skillful abilities. She conferred with me at every stage, critically reviewed the entire manuscript, and contributed many valuable suggestions. Her help and encouragement have been invaluable.

Feng shui

Part I

Basics

WHAT PLACEMENT ART IS

Feng Shui Awareness

Whether or not we are conscious of it, our surroundings influence us continuously; even when we don't realize it, we experience feng shui. When we walk into an unfamiliar space and feel welcome and at ease, we are responding to skillful feng shui. On the other hand, when we are in a place with unfortunate feng shui, we usually find ourselves looking for the nearest exit, or if we are caught there for a period of time, we might find ourselves compulsively searching for the nearest coffee or candy machine, or dumbing down and numbing out. How much time do we spend in places we would rather not be?

The Chinese words "feng shui" translate as "wind/water." Wind and water are among the fundamental elements that govern nature. All of life depends on wind and water; nothing lives for long without them. The natural tendency of wind (the air around us, our breath) is to expand, while the natural tendency of water is to form a sphere, to contract. The combination of these opposing forces—expanding wind and contracting water—produces motion. This motion translates into subtle but powerful currents. An

feng shui

example of these currents is planetary weather, the flow and exchange of wind and water around the earth. Imagine a United States weather map in January. Cold dry air flows out of the Arctic and funnels south between the Rocky and Appalachian mountains. When other air, like warm wet Gulf of Mexico air, meets the Arctic air mass, storms are produced. These storms are depicted on the weather map as circles and lines, symbols graphically representing the interface of forces that have the potential to produce tremendous energy.

This same interface of wind and water forces pervades all levels of our lives. All the permutations of the universe resonate around and within us through wind and water dynamics, and create "the one living tide that moves within us all," as Joseph Campbell calls it.☞ The flow of this living tide through our everyday surroundings—an invisible force within our visible world—is the flow of feng shui. Learning to intuit, visualize, and adjust energy flow lines around and between objects is the practice of feng shui.

☞ Joseph Campbell, *Historical Atlas of World Mythology*, vol. 2, *The Way of the Seeded Earth, Part I: The Sacrifice* (New York: Harper and Row, 1988), p. 8.

Early feng shui practitioners studied a site by crawling over it on their hands and knees. In this intimate and pragmatic way, they sought to discover the forces at work in the landscape. Fortunately, it is no longer necessary for us to crawl over the ground to read a site, since we are able to take advantage of more than five thousand years of feng shui study and practice.

The feng shui system is rooted in the beginnings of agriculture in China. As Kwan Lau tells us, "Feng shui shares its historical development with Chinese astrology and divination. It dates back to mythological times, although no reliable historical data tells us when and by whom it was first conceived."☞ Only fragmentary information and indirect references from the beginnings of feng shui practice survive today.

☞ Kwan Lau, *Feng Shui for Today* (New York: Tengu Books, 1996), p.17.

As feng shui grew and developed, specialists in its practice created schools and lineages, their knowledge passed down by oral transmission. Several schools of

feng shui currently exist, as does a legacy of classical feng shui texts, some dating from the ninth century.⤸ Feng shui has been systematized and updated into a body of knowledge that teaches us what does and what does not constitute a healthy and balanced environment.

⤸ Lillian Too, *The Complete Illustrated Guide to Feng Shui* (Shaftesbury: Element Books, 1996), p. 18.

Traditional cultures around the globe recognize the interdependence of the environment and the people living in it, and have developed an understanding of the best way to orient themselves within their surroundings. For instance, the European term for this practice is geomancy. Historically, geomancers were consulted before any noteworthy building was undertaken. Geomancers determined the placement of the cathedrals and other holy places in Europe. One of the practices of geomancers was to locate important sites over underground energy lines.⤸ In so doing the site was invested with a natural aura, helping to increase the power of these places for visitors.

⤸ Nigel Pennick, *The Ancient Science of Geomancy* (Sebastopol: CRCS Publications, 1979), p. 38.

What many of us are coming to discover as the twentieth century draws to a close is that harmony and balance have been lost to us in the modern urban landscape. We are rediscovering what geomancers and feng shui advisors have known for eons: well-being and sanity require that we accommodate natural energy patterns rather than manipulate nature to fit our post-industrial schemes. Feng shui guides us back to a natural harmony with our world. In this respect, feng shui takes its place within the expanding science of depth ecology.

People hearing about feng shui for the first time frequently remark that it is just common sense. This is true. At heart, feng shui is simple common sense, which is defined in Webster's Unabridged as "normal native intelligence." Finding surroundings that protect and promote our survival is a basic human instinct. Moreover, the first decision made in human life is one of placement. Once fertilized, the microscopic embryo

in the womb seeks the spot that will provide optimum support for its life and locates there. From the very beginning and throughout our lives, finding surroundings that sustain and nourish us is a requirement for survival, and since feng shui is based on locating and creating advantageous, beneficent places, it seems to be common sense to people when they first encounter it.

Before we began living in cities—a mere eight thousand years ago—we were intimately linked with our surroundings. In spite of living in artificial environments as we do now, we are nevertheless bound to the natural world through our genetic imprint. Even as we continue to evolve beyond basic survival and adopt lifestyles that tend to separate us from the natural world, the forces that shape us still, from the instant sperm meets egg, are the forces of wind and water.

Where and how we live is immensely significant to our inner and outer life. The forces inherent in our environment either drain or enhance our potential. What kind of feng shui awareness have we applied to our surroundings? What consciousness went into creating our world? What state of mind is physically expressed around us? "It's time to play by more conscious rules," Caroline Myss tells us.☞

☞ Caroline Myss, *Energy Anatomy* (Boulder: Sounds True Audio, 1996), tape 2.

Basic to feng shui is a realization we may not want to accept: we are affected by everything in our environment. In fact, this view could make us anxious and ill at ease, especially when we are in early stages of developing feng shui awareness. What undiscerned aspects of our environment are impacting us? How do we go about the process of placing ourselves well? Where do we start? Common sense may dictate some things, but how to learn the rest? How can we arrange ourselves in our surroundings so as to be available to the positive, enlivening, flowing energies that are all around us, while avoiding the harsh and piercing ones?

Once we begin to cultivate feng shui awareness and understanding, and are able to arrange our world

through the tools that feng shui makes available to us, we can begin to relax. At last we have a way to organize ourselves and our surroundings that places us in harmony; we are aware of our environment and its impact on us, and are well-placed within our world. Good placement supports our personal power, and we find ourselves in a position to improve and amplify our well-being and prosperity.

The Power of Place

Modern science now supports the view that we are intimately connected to our environment. Especially since the 1960s, this interrelationship has been investigated by a variety of environmentally-minded scientists in areas of study with intriguing names: environmental psychology, developmental pediatrics, behavioral biology, biophysiology, electrochemistry, neuropsychopharmacology, and biomolecular electronics are just some of the specific scientific fields contributing to an expanding body of knowledge.

Many studies have linked geography and psychology. Haven't we all heard of the studies which show the importance of adequate light in staving off depression in long Alaskan winters? Environment and behavior correlate; we know that people watching soccer games exhibit far different behavior from people enjoying a symphonic performance. Ambiance and human development are known to interrelate; it is clear that children raised without sufficient stimulation tend to fare poorly in school, as do children growing up in chaotic, crowded, noisy inner city neighborhoods. The effect of our surroundings on our health is continually being explored and elucidated. The so-called "sick building" syndrome is one example. Chronic respiratory illnesses are frequently suffered by people working in buildings with windows that don't open and air systems that

recirculate internal air rather than bringing in fresh air from the outside.

That we are part of a dynamic feedback system has been demonstrated microscopically, at cellular and genetic levels, as well as macroscopically, in studies of population groups. It is known, for example, that our experience of a devastating loss can create chemical changes in our body. These chemical changes affect certain brain proteins that make us more susceptible to depression in the future. Further, it is known that our emotional responses are linked to our surroundings; when we return to a place where we experienced strong feelings, that place, regardless of what is happening there in the present, can evoke an emotional response similar to the one we experienced there in the past. Moreover, these emotional responses can linger at a site and impact subsequent visitors. The Vietnam War Memorial in Washington, D.C., the Blarney Stone in the county of Cork, Ireland, and the Wailing Wall in Jerusalem are some examples of places that elicit common responses from visitors.

Nothing is fixed; our world shapes us as we change our world. Research in the past twenty years has shown that eighty-five percent of brain growth takes place after we are born. Most of our brain develops through our senses reacting to stimuli in our environment. Brain size and structural development is basically complete by puberty. However, "even after the brain has attained its maximum size and structure, signals from the body and the environment are still constantly changing it," Gloria Steinem says.c⊛ We are infinitely adaptable and flexible beings literally created from our surroundings even as we create them. Our choices shape our lives. Not only are we affected by climatic changes brought about by our pollution, we experience personal microclimates resulting from the clothing we choose.

All this research makes fascinating reading and attests to the powerful influence of our places on us.c⊛

c⊛ Gloria Steinem, *Revolution from Within* (Boston: Little, Brown & Company, 1992), p. 320.

c⊛ Winifred Gallagher, *The Power of Place* (New York: Simon & Schuster, 1993).

As the scientific discoveries progress, even more elusive aspects of our surroundings are being studied, including subtle environmental fields of energy: electrical, magnetic, electromagnetic, and ionic. As monitoring equipment gains sophistication, we will learn more of the effects of these fields on us. These energies are part of the earth's milieu and we are immersed in them throughout our lives.

Scientists monitoring the earth's electrical field have found it to be stronger in areas with subsurface geologic stresses. Like the earth, people also have an electrical field, and research has found that electrical fields generated outside us, like those present near geologic stresses, influence our brain waves and hence our states of consciousness. In addition, our brains have been found to have magnetic sensors, tiny deposits of magnetite that may serve as a natural built-in compass. The shamans of old, our feng shui ancestors, did not have scientific instrumentation to demonstrate fluctuations in electrical or magnetic fields. But no doubt they were extremely sensitive and aware, and when they felt that a particular spot was special and chose it as a place of power, they were sensing reactions in their own nervous systems to changes in these fields.

Living in modern artificial environments, with layers of conflicting and confusing energies, has separated us from a personal intimacy with the natural world, even though the receptors are still in us. Our reliance on science and technology masks the innate abilities our bodies possess to fully experience our world. Current scientific testing of human responses to changes in subtle energy fields has not shown consistent results because individuals vary greatly in response to these fields. But these tests have shown that hormone levels, attention levels, and environmental factors are some of the variables known to affect sensitivity.↩

↩ James B. Beal in *The Power of Place*, ed. by James A. Swan (Wheaton: Quest Books, 1992), p. 289

Intuition is a gateway to conscious experience of these subtle energy fields. Feng shui practice, as with dowsing and related arts, functions in the intuitive

realm, which until recently was considered mystical—even mumbo jumbo by some—and outside the bounds of science. We are now understanding it differently. The good news is that our feng shui skills and sensitivity develop together, and we can uncover latent body responses and feelings that open us to the power of places.

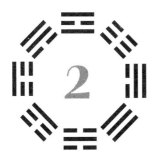

Feng Shui Vocabulary

As we study feng shui, we discover that the basic principles underlying it are thousands of years old, steeped in wisdom and deep meaning. In this chapter we look at the concepts of Tao (pronounced "dow"), yin, yang, chi, and the Five Elements. If we familiarize ourselves with these concepts, we will be better equipped to help ourselves with feng shui.

Tao is the eternal ground of all things in the universe. Hua–Ching Ni says, "The term 'Tao' indicates something unnameable, indescribable and indefinable. Everything has its own way, yet all ways follow only one way that exists for all times. This is called 'Tao' or simply the 'Way.'"∽ Tao also refers to the process of people harmonizing with the universe by means of natural laws, and is the basis of a philosophy that integrates thousands of years of Chinese customs and insight. The fundamental Taoist concept of the interconnectedness of all things is the basis of the feng shui premise that everything in the environment affects everything else around it. Nothing exists sepa-

Tao

∽ Hua-Ching Ni, *The Book of Changes and the Unchanging Truth* (Santa Monica: Seven Star Communications, 1994), p. 665.

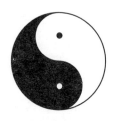

yin-yang symbol

rately; all is linked through a pattern of cycles or rhythms. Everything is connected, and everything is always changing.

The pattern of motion connecting everything is a continuum between the opposing but complementary principles of yin and yang. Yin and yang are the forces that propel the world and everything in it: the seasons, the times of day, temperature and weather, rising and sinking. All cycles of life are made up of yin and yang and all things in the world are in a constant state of interaction, ebb and flow, between these two. Neither yin nor yang exist totally in isolation. Nothing does, nor is anything ever absolutely at rest. We know that the atmosphere, for example, is always in motion, rising and falling: thermals float upward in strings or chains off objects heated by the sun, multiple streams of bubbles rising everywhere around us, which then return to the earth as precipitation. Rest, like the pendulum at the height of its swing, is merely an intermediate state of movement. Yin is always moving toward yang, yang is always becoming yin, and, in fact, when pushed to the extreme, they reverse themselves. This reversal frequently happens on speedy highways at peak traffic times when the pace slows way down, or even stops. When yin and yang are balanced, as in the familiar yin–yang symbol, harmony and well-being result. In the *I Ching* or *Book of Changes*, we read: "In the sphere of human affairs, the condition of harmony assures good fortune, that of disharmony predicates misfortune."↷

↶Richard Wilhelm, trans. (English translation by Cary F. Baynes), *The I Ching or Book of Changes* (Princeton: Princeton University Press, 1967), p. 283.

The yin force is tangible, stable, calm, soft, feminine, receptive, passive, responsive, yielding, cool, and associated with night, winter, and darkness. The yang force is intangible, expansive, active, hard, masculine, outgoing, creative, assertive, forceful, warm, and associated with day, summer, and light. As R. L. Wing says,

> Yin and yang represent the negative and positive dualism existing within all things, from the elec-

trons and protons of the atoms to the uncon-
scious and conscious of the human psyche. Yet
they are not considered opposites at all, but
interdependent polarities that bring all of exis-
tence into being."

↬ R.L. Wing, *The Illustrated I
Ching* (Garden City: Doubleday &
Company, 1982), p. 14.

Everything is related through these parents of all
phenomena, yin the mother and yang the father. The
lines of relationship between them—the flow of ener-
gy—is chi.

Chi is the force energizing all things. Everything has
chi, and in the practice of feng shui we learn to per-
ceive the quality, flow, and interplay of our chi with
the chi of our environment. As we look at a landscape,
a building, or any kind of space in our search for a
balanced place, the chi of place communicates to us.

chi

Think of chi and what it communicates as energy
and effect. Everything has energy and effect in some
form—in fact, energy and mass (matter) are nearly
equal (e=mc2) and can be neither created nor
destroyed: they only change appearance. The material
world is an atomic structure held together by the elec-
tromagnetic forces we call energy: available, limitless,
describable, and transferable. It's all energy, and this
energy is chi. Chi is not a mystery; it simply is what is.

All of us have chi; it carries our body and stays with
us our entire life, through all our changes. Yet its char-
acteristics and the way it moves us are different in
each of us, forming the ground of our uniqueness. Our
personal chi is what influences others. Chi creates our
life's story and is our destiny. Just as the goal of
acupuncture is to tap a person's chi, the aim of feng
shui is to engage the earth's chi.

Land that is the most inhabitable and nurturing is
land that is most influenced by chi. Chi must flow
smoothly, near the surface, and be balanced, not too
strong or weak, too yang or yin. Since the circulation
of chi is essential to the maintenance of balance and
well-being, feng shui seeks to harness and enhance

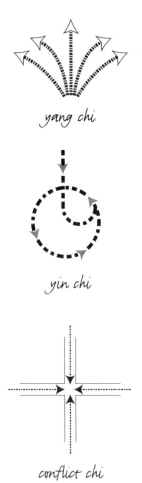

yang chi

yin chi

conflict chi

environmental chi and improve its flow. An improved flow of chi—which in this context is the same thing as opportunity— improves our life and destiny.

The more we know about how chi behaves, the more we perceive it. Chi can rise, fall, disperse, pool, or settle. Its flow can be fast, slow, or stagnant. Yang chi ascends and moves outwards; yin chi settles and pools. A vortex forms at surfaces of contact between bodies of opposing chi, where there is always a tendency for one layer to roll upon the other and create a suction in the center. We see this in a glass when we stir cocoa vigorously into milk. Corners, tunnels, and edges attract and radiate negative chi. Negative, depleting chi zeros in on anything straight, which is the reason straight lines are avoided. A meandering line may take longer to traverse than a straight line, but it energizes whatever is moving along it. As we walk along a meandering garden path, for instance, our perspective constantly changes and we discover new scenes to view and enjoy. Enclosed spaces, basements, and storage areas exhaust and stagnate chi—most of us sense this when we look in our closets. Crosscurrents of chi can generate patterns of conflict—the reason traffic lights were invented. Chi can be expressed through form, direction, color, or the feeling it generates. In the next section, we will look at these aspects of chi by examining the cycle of the Five Elements: water, wood, fire, earth, and metal.

But first, let's look at some ways chi impacts our personal space. Closing our bedroom door restricts who may enter and helps preserve our inner refuge. Open areas, available to everyone, are where social gatherings take place. A spiral staircase can be difficult for people with disabilities to use. A ramp makes it easy for a chair to be wheeled into a building. People will often yield to the sight of a water feature near the front door and enter a place they intended to just pass by, while they often resist entering a place with a list of prohibitions posted by the front door.

Water moving slowly in a meandering stream is subjected to currents that purify it; water that flows fast through a straight concrete channel, like the barren Los Angeles River so often depicted in chase scenes in Hollywood films, attracts pollution. A smooth fabric is inviting; contact with a rough wall surface may damage skin. A simple transition between the world at large and our arrival in our home helps us relax; when we drive our into our garage and have to maneuver around trash cans and up short side stairs to get into our home, often entering through a laundry room, we end up with a complicated and burdened sense of what returning home means. Unfortunately, modern design is choosing more and more complex patterns in home design.

Our understanding of chi develops as we learn to see the symbolism inherent in our lives. After all, the environments we create signify our consciousness; they are a mirror of our thoughts and a reflection of our state of mind. Feng shui uses a nonjudgmental, all inclusive vocabulary—closed, open; difficult, easy; yielding, resisting; slow, fast; smooth, rough; simple, complex; obstructed, clear; secure, exposed; stagnant, flowing; contracting, expanding. These are just some of the conceivable descriptions of chi. Each of these impressions is valid and useful, and each has its place. When we can detect their expression in our surroundings, when we use feng shui awareness to perceive the chi in our environment, we hear our world speaking to us, and when we look carefully we see our own reflection.

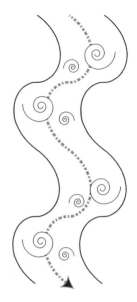

meandering stream with purifying currents

The Cycle of Transformation

The cycle of transformation is a way of symbolizing stages of change. As things change—yin transforming into yang and then yang developing back into yin—the stages of change follow a pattern. This pattern, or

process, is depicted in five phases. These five phases of change characterize all matter and are the same energies an acupuncturist works with in a person to bring their body to balance. Along with yin, yang, and chi, the process symbolized by the five phases adds a way of analyzing and harmonizing our spaces. These five phases are known by the natural elements associated with them: water, wood, fire, earth, and metal.

The five phases are also delineated by many other attributes such as form, color, activity, direction, time of day, season, time of life, and emotion. The cycle of transformation is commonly expressed in two different fixed arrangements. In the creative cycle, each element generates or complements the next; in the controlling cycle, each element conflicts with, or destroys, another. Objects are a composite of the elements, but some exhibit qualities of one element more strongly than another. When objects are placed so that they complement each other, harmony is enhanced. When things are placed so that they conflict with each other, the effect is neutralized, or controlled.

Let's begin with the creative, generating, or complementary cycle. The order of this cycle is wood, fire, earth, metal, and water. We can begin the cycle at any element, but starting at the wood element makes sense because it represents the newness of things. The wood element is cylindrical, green, generative, the east, morning, spring, infancy, and, in people, is expressed as compassion. Columns, poles, tall thin buildings, all manifest the wood phase and its ability to get things going and raise energy. Bamboo represents the wood element because it has the shape, color, and strong upward growth force synonymous with the wood element. The next element, fire, is generated by burning wood.

The fire element is conical, red, expanding, corresponding to the south, midday, summer, youth, and is expressed in people as reason and understanding. The upward aspiration of fire reflects in buildings where people aspire to higher things. Spires, pointed roofs,

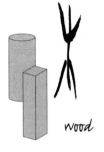

wood

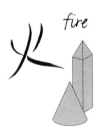

fire

and triangular or conical shapes, traditional in the construction of churches and universities, all express the active fire phase. Artists tend to be attracted to fiery, conical shapes in spaces with lots of corners sticking out and with unusual orientations. The lightning bolt shape, for instance, is powerful and may be perfect for people involved in creative work, but it often requires careful adjustments to balance out the sharp energy. Fire transforms during burning and generates ash, or earth.

The earth element is flat or square, yellow, gathering and stabilizing, is the center, mid-afternoon, late summer, maturity, and is expressed in people as trust and integrity. The earth element is grounding and receives things, is low or squat, and good for storage. When seeking a new building to house an expanding business, it would not be wise to choose an earth shape; however, the earth shape is perfect for warehouses. In the years after World War II, a period fondly remembered for its secure stability, low, boxlike houses gathered in suburbs throughout the United States. Solidifying earth forms the next element, metal.

earth

Metal is dome- or arch-shaped, white, concentrating or condensing. It corresponds to the west, evening, autumn, old age, and is expressed temperamentally in people as righteousness and purity. Government buildings and libraries often incorporate domes, fitting for virtuous activities. Condensation forms on a metal cup filled with cool liquid. This process mirrors the movement into the last phase of the creative cycle, water.

metal

The water element is an irregular shape, black, conserving, represented by the north, midnight, winter, dormancy or death, and is expressed emotionally in people in two ways: still water manifests as clarity of mind and wisdom; moving water expresses itself in people as social interaction, drive and effectiveness in society. A water-element building has a floating irregular shape, a roof line that curves and indents and is not easily categorized by any one geometric form.

water

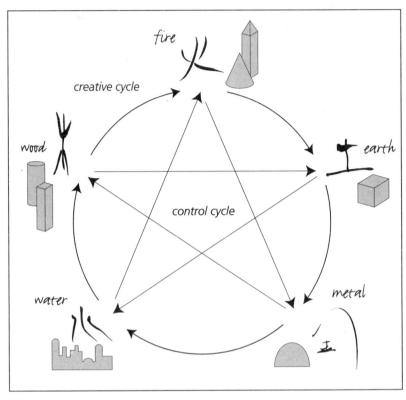

Cycles of the Five Elements

Buckingham Palace reflects a water element form, as does the Manhattan skyline when viewed from a few miles away.

The creative cycle is symbolized as a circle, the control cycle as a star within this circle. The control cycle is based on conflicting or destructive relationships between elements. Wood, in growing, uses up earth; therefore, wood destroys earth. Fire melts, or conflicts, with metal. Earth dams, or controls, water. A metal ax cuts, or destroys, wood. And water extinguishes, or controls, fire. A healthy respect for the power of the five phases and their order is useful as a guide, although in feng shui awareness practice, chi is the most important concept.

The Bagua

The bagua (pronounced "ba gwa") is the feng shui blueprint for achieving harmony and balance in arranging the spaces in which we live and work. Balanced place energy resonates with our personal energy, creating an alignment between the external and internal that we experience as a feeling of wholesome equilibrium. When we feel balanced, we operate from a position of open clarity that allows us to recognize the symmetry, proportion, harmony, and sanity in the energy that flows around us—energy that belongs to no one, cannot be owned, and yet is always available to us when we do not impose restrictions and limitations on it. When we use the bagua to adjust our spaces, we better perceive the opportunities offered by this appropriate and healthy flow of chi into and through our environment and, as a result, our choices and our lives improve.

Bagua means "eight trigrams," symbols delineated in the *I Ching*, an ancient book of divination that took its final form during the Chou Dynasty in China, a few centuries before Christ. The trigrams are made up of a series of three solid lines, three broken lines, or combinations of the two in all possible permutations—for a total of eight basic arrangements. The solid, creative, yang line represents presence; the broken, receptive, yin line is absence—an ancient graphic depiction of the binary system used by computers today. Tradition holds that before written history, Emperor Fu Hsi developed the lines and trigrams to express the natural order.

The eight trigrams represent archetypal family roles as well as manifestations of universal energy: father, heaven and strength; mother, interdependence and nourishment; eldest son, thunder and movement; middle son, water and enterprise; youngest son, mountain and contemplation; eldest daughter, wind

ch'ien

k'un

chen

k'an

ken

sun

li

tui

the eight trigrams

and dispersal; middle daughter, fire and illumination; and youngest daughter, lake, rain, and joy.

The nine sections—eight sides plus the center—of the bagua octagon correspond to the nine ingredients of a balanced life. Equal in value and weight, presented clockwise beginning at the bottom, these nine are: 1) career—literally what we do to make money—and also our journey through life; 2) knowledge, and education of all kinds, including contemplation and self-discovery; 3) family (of birth and of choice), the source of our values; 4) prosperity and the fortunate blessings of wealth; 5) fame and reputation, or our illumination in our community; 6) relationships, and partnership with significant others; 7) children, and creative endeavors; 8) helpful people (patrons, friends, subordinates), or helpful situations, as well as travel; and last, in the center, what everything else turns around, 9) health.

Five of these areas correspond to the five elements. Career is water, representing wisdom and social interaction combined. The family area corresponds to wood—also depicted as thunder, or dynamic energy coming to the earth from the heavens—because of its associations with generation and growth. Fame and aspirations illuminate like fire, while our children and creative projects, a concentration or condensation of our energies, are metal. Earth, and the health it nourishes occupies the center, the heart of balance. This bagua arrangement of the elements in feng shui follows the creative sequence of the cycle of transformation and adds four more trigrams between the elements to form the octagon. These four additions—the mountain of knowledge, the wind of wealth, receptive relationships, and heavenly helpful friends—amplify and enrich a truly balanced existence.

Though rooted in ancient mysticism and designed to represent cosmic balance, the bagua is applied to everyday life in a practical way. Feng shui practitioners simply memorize it and then mentally superim-

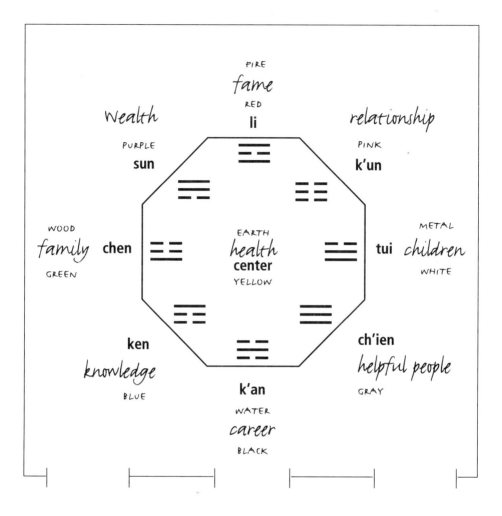

FIRE
fame
RED
li

Wealth

PURPLE
sun

relationship

PINK
k'un

WOOD
family **chen**
GREEN

EARTH
health
center
YELLOW

METAL
tui *children*
WHITE

ken
knowledge
BLUE

k'an
WATER
career
BLACK

ch'ien
helpful people
GRAY

The Bagua Octagon

pose it on a piece of land, a lot, building, room, desk, and even the bed. The orientation of the bagua on the space is determined by the entrance or door to the space, and can be applied to rooms, homes, or lots of any shape and size.

We orient the bagua by the front door, or the door the builder or architect intended as the main entrance,

Bagua Orientations

The bagua always aligns on the door or entrance of a space, flexibly changing its shape and orientation as it is applied to different lots, buildings, rooms, and even major items of furniture such as beds and desks.

① career
② knowledge
③ family
④ wealth
⑤ fame
⑥ relationship
⑦ children
⑧ helpful people
⑨ health

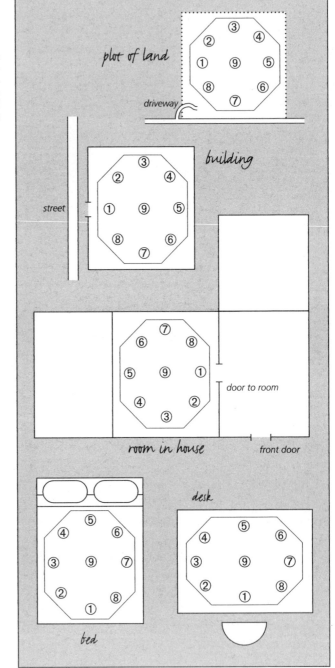

plot of land

driveway

street

building

door to room

room in house

front door

bed

desk

and not the door we may use the most because it is convenient. When applying the bagua to land or lot, consider the driveway or road onto the property as the main entrance. Where we sit at our desk is its entrance; the foot of the bed is considered its entrance. When superimposed on the space, the bagua is not oriented with the cardinal directions, but rather, is turned so that the knowledge, career, and helpful people areas of the bagua line up along the wall or part of the property that has the entrance. This means that the north portion of the bagua is always aligned with the entrance, no matter what direction the entrance itself may face.

From the Chinese point of view, in Earth's northern hemisphere, the pivot point of the heavens is the North Star, or Polaris. Polaris is the supreme commander of all stars since all constellations and stars revolve through the four seasons around it. In Chinese mythology, Polaris symbolizes the beginning of order, hence the use of north as the focus for orienting the bagua—as above, so below, or, the beginning of order for the heavens is the beginning of order for us—which also explains why all opportunity comes to us through our main entrance, the mouth of chi.

When we superimpose the bagua on the space, the flexible and ever-changing bagua adjusts to the size and shape of whatever it is applied to, so that each of the sections occupies approximately one third of each side of the space. Since the bagua superimposes most easily on uncomplicated shapes like squares and rectangles, these shapes are considered the simplest to balance. Although interesting, other shapes may create unfortunate missing areas or other problematic situations like blocking walls or cutting edges. On the other hand, some design features create fortuitous enhancing projections (see illustrations on page 40).

The application of the bagua is simple: adjust or cure the area of the bagua you wish to change or enhance. Want more wealth? Work on the wealth area.

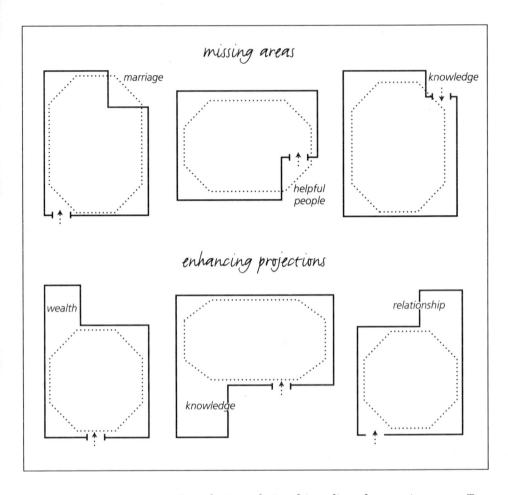

For a better relationship, adjust the marriage area. Too famous, or not enough? Adjust that area. The feng shui solutions or cures used to attract or repel energies in the various sections include crystals, wind chimes, fountains, statues, and even firecrackers. In general, the solutions are simple, but the results are often dramatic. Applying the cures and watching for the resultant changes is part of feng shui. Since everyone bumps into trouble and misfortune, the bagua is used both as a guide to interpreting problems and as a key to resolving them. But its most beneficial purpose is as a map for designing a balanced and centered life.

chi

Part II

Practice

HOW TO USE PLACEMENT ART

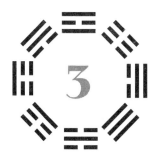

Finding a Home: External Factors

Basic feng shui guidelines for finding the best place to live evolved thousands of years ago in China, and still apply today. Long ago, perceptive observers came to realize that surviving was easier in some locations than it was in others. In fact, certain locations provided more than just survival for their inhabitants—those who made their homesteads in what came to be understood as ideal sites lived successful and prosperous lives.

In our pursuit today of the best dwelling place, an acquaintance with the parameters of the ideal feng shui site gives us an advantage—with this knowledge we can discern latent possibilities inherent in the various sites we encounter in our search. The ideal feng shui site provides a foundation for understanding what ingredients to look for and which ones to avoid. For instance, homes built on river floodplains, in coastal areas subject to annual hurricane alerts, or on mountaintops each have risks associated with them that are helpful to know of as we explore.

The ideal feng shui site is described as being halfway up a hill, at the point of balance and transi-

tion between the two extremes of wet, condensing, yin energy at the bottom and dry, expanding, yang energy at the top. The ideal site is located on the south slope, to gain maximum benefit from the sun (of course, this is true only in the northern hemisphere; in the southern hemisphere, the perfect site would face north), and has a forest or bank of soil uphill from the dwelling, a body of water below, and two small hills or forests on either side. This classic feng shui site is safe and sheltered, protected from harsh winter winds, afforded optimal sun, and provided with access to water while at the same time being safe from floods—a situation that facilitates the survival and prosperity of its inhabitants. As Sarah Rossbach explains it,

☞ Sarah Rossbach, *Interior Design with Feng Shui* (New York: Arkana, 1996), p.32.

> This classic feng shui arrangement is traditionally described as a sort of mountain menagerie: the house is protected from the northern wind by the black tortoise mountain in back; the white tiger to its right blocks the malign western sun glare; the green dragon to the left guards the site if the ferocious white tiger gets out of hand; the red phoenix in front is low enough to allow a vista but high enough to protect the site and its inhabitants.☞

Because its topography resembles a comfortable armchair, it is known as the armchair location. However, as we search for such a site, we soon discover that ideal locations are difficult to find and acquire. The art of feng shui has developed in response to the needs of people not able to locate in the ultimate, auspicious place.

A feng shui analysis of a potential home site includes consideration of the favorability or unfavorability of the following external factors: the shape of the land and its features, vegetation, bird and animal life at or near the site, watercourses, traffic and road influ-

black tortoise

white tiger

green dragon

red phoenix

The Ideal Feng Shui Site

ences, proximity to power lines and transformers, approach and accessibility, and the character of the surrounding neighborhood—or as the real estate people say, location, location, location!

When we use feng shui awareness to choose a home site we scrupulously consider everything in the vicinity, seen and unseen. While some unseen factors are insignificant, others are important. Unseen factors that require careful thought are the various earth-energy lines: underground waterways, dragon lines, song or ley lines, fault lines, lava tubes, or any other invisible power conduits under the location. Many feng shui experts dowse for these powerful influences, while other sensitive and knowledgeable feng shui practitioners recognize these influences through intuition and observation of subtle surface clues—wildlife pathways, cracks in the ground or pavement that indi-

cate settling, broken tree branches or trees growing in deformed shapes, dead or diseased plants, and odd wildlife occurrences.

These unseen elements are known to affect the lives of people who live over them. My client Paul said he just didn't sleep well. We discovered underground lines of force running under his bed, and Paul's solution was to divert them around the bed with a heavy copper wire. After the wire was in place Paul slept better, and his back, which had ached constantly before he made the energy adjustment to his bed, soon stopped hurting.

Whether or not we live over these various power conduits is largely a matter of personal choice. Some people enjoy the heightened sense of intensity these lines bring to a locale and deliberately seek them out. The points at which these intense energy fields surface are power spots, special sites some people search for as places of ritual and spiritual practice. Living over them, however, may bring physical or mental health problems to a household. Knowing about these potent unseen factors in advance can guide our decision-making process.

Unseen factors that have little consequence in our selection process for a site are surface features that are not visible from the site itself—if it isn't within our field of vision, it need not necessarily be heeded. A cliff on a large piece of property may have a menacing quality, but if it cannot be seen from the dwelling, it should not adversely impact the residents. A measure of caution seems advisable here—intelligence dictates that we study the area for miles around the site, especially upwind and upstream, for other dangers not visible from the site. People who lived several miles downwind of Chernobyl may not have been able to see the nuclear power plant before the accident, but when it spewed radiation into the atmosphere they were negatively affected.

The shape of the land under consideration is explored two-dimensionally, on a map or plat, as well as three-dimensionally through an examination of topography and surface features. When pondering the map or plat, remember that an ordinary shape like a square or rectangle is the simplest to balance, and is thus preferred. Other shapes are judged for any associations they may be seen to exhibit. For instance, a lot that is narrow in front and wide in back is the highly favored money-bag lot because, like a bag for valuables, this shape allows good energy to enter through a narrow opening and accumulate at the wide back. The opposite-shaped lot, wide at the front and narrow at the back, is associated with a dustpan, and is considered unfavorable because the energy comes in and is stifled at the rear.

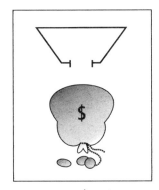

moneybag lot

Worse than the dustpan lot is the pie-shaped lot, which comes to a point in the back. This shape is missing both the wealth and relationship sectors of the bagua. Carolyn was excited about the old house that was her first home purchase, and called for a feng shui consultation soon after she purchased it. When the bagua and its position on her lot were explained to her, and she realized that her pie-shaped lot was missing the wealth and relationship areas, the look of disappointment on her face spoke volumes. She said, "I want to have an easier time with money and I very much want a relationship. I should have had you come look at this place before I bought it!"

dustpan lot

Investigation of the three-dimensional aspect of a piece of land includes scrutiny of all the topographical features of the landscape. Is the land steep or flat, rocky or smooth, wet or dry, mild or wild? Does one landscape feature dominate all others and if so, what is its nature? What is the orientation of the site? Consulting a topographical map reveals much about a piece of property, but the greatest insight is gained by walking around on the tract. Observing it through the course of

a year and experiencing a complete cycle of the seasons before contemplating building or changes is also extremely informative and highly recommended.

Another aspect of a piece of property that provides valuable evidence about its possibilities is its history. What events have taken place here in the past? Did the previous owners have fortunate lives while owning this place, or did they suffer problems like illness, bankruptcy, and divorce? Why are they selling it? Are they moving on to something more, or less? An ideal situation is one in which the previous owners are selling in order to move on to something bigger and better.

The energies associated with places linger. Mindy was having problems in her life—problems which began soon after she moved into her new home several years ago. Her marriage failed; her young son nearly died of a rare disease that required expensive treatment not covered by her health insurance; her daughter suffered injuries; and finances were a continuing and very real problem. As I questioned her during her feng shui consultation, she revealed that her neighbors were experiencing many of the same problems. One neighbor across the cul-de-sac from Mindy had died recently; other neighbors were separating or divorcing. They all lived in large, stately homes in the piney woods close to Kennesaw Mountain, Georgia. Kennesaw Mountain is commemorated as the site of a bloody Civil War battle and was a battleground for Native Americans as well. Mindy told me that she and her children often found minié balls, old bullets, and arrowheads on their property, so it had long been a zone of strife.

The next external factor we note as we investigate a potential site is the vegetation on and near the site. Are the plants plentiful and healthy, and is there a variety of species? If we arrive at the site and find kudzu or Hawaiian banana poki growing over every-

thing, we know we have a definite dilemma with that particular property.

The quality and quantity of the vegetation is a fairly obvious sign. The bird and animal life at or near the location may be more difficult to observe. If we have the good fortune to see them, or see evidence of their existence on the site or in the neighborhood, we have a clue about the property. If birds are absent altogether, or if the birds or animals there are aggressive or sickly, we have another form of evidence. Deer sightings are especially auspicious near a site; sightings of rattlesnakes and other poisonous or dangerous animals are unfavorable, although sightings of non-poisonous snakes may be viewed as a positive sign—the snake, which sheds its skin several times a year, represents transformation and potency, and is the symbolic animal at the center of the bagua.

Clear, flowing water on the property is very beneficial. Flowing water brings energy to us even as it fills the air around us with negative ions that neutralize air pollution and other contaminants. The best position for moving water, like a creek or pond, is at the front of the property, especially if the creek or pond bends toward, or better yet, encircles the front of the residence. Amsterdam comes to mind; its canals channel through a flourishing and affluent city. Flowing water in front brings positive energy to our door. In addition, the bagua section in the middle front of the property and home is the career area. The career area is associated with the water element and a water feature at the water element position brings balance. However, even if there is a creek at the back, in the fame area ruled by the fire element, it is not thought troublesome as long as its banks are high enough to block the view of the flowing water from the abode. Flowing water in other areas may be thought of as favorable or unfavorable, depending on the situation—configuration of the watercourse and the amount of flow in it are

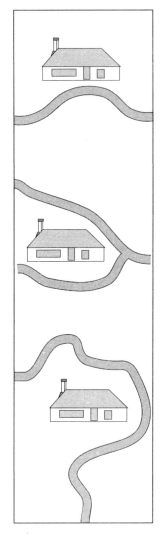

beneficial waterways

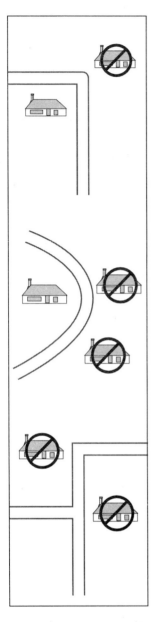

favorable & unfavorable
road positioning

examined. Stagnant or polluted water anywhere on or near the site is unfavorable.

Road and traffic influences on a location merit careful consideration. Are roads or bridges pointing right at the site? The energies traveling on roads and over bridges are speedy, polluting, and dangerous. The term roadkill may be a rich source of material for jokes, but it also aptly describes the effect of these influences on the lives of people who suffer daily onslaught from these conduits of negative, driving energy. Roads or bridges pointing at the site bring too much energy. Freeways and major thoroughfares suck the energy from everything near them, depleting the people who live close by. Homes on corners, at Y-intersections, or at five-cornered intersections, are subjected to conflicting energies. Homes at the end of T-intersections are for sale or for rent more often than other homes nearby. Homes at the base of cul-de-sacs are particularly vulnerable, because they have intense energies focused toward them each time a vehicle drives down the street, whether its final destination is the home at the base of the cul-de-sac or not. At night, the lights of every car driving on the street will shine in the front windows of the home.

When Betty called me to her home for a consultation, one of her concerns was her difficulty in getting a good night's sleep: she couldn't seem to calm down and rest in her bedroom. Together, we looked out her bedroom window and saw a sidestreet aimed directly at it. When George and Yvonne retired, they bought a mobile home at the rear of a mobile home park immediately adjacent to the Pomona Freeway in Los Angeles. The freeway is four lanes wide in each direction as it passes the park, and George and Yvonne's bedroom was about twenty feet from it. They were both restless at night and had trouble sleeping the whole time they lived there, some twenty years, before they both died of cancer. Feng shui offers solutions for

these situations, but avoiding the problems in the first place is favorable.

The effects of electromagnetic fields produced outside our bodies is a topic of much debate and study.☙ Electromagnetic stress is defined as metabolic disruption caused by electromagnetic interference.☙ Since our bodies function by means of our own natural electromagnetic signals, environmental electromagnetic fields have the potential to interfere with and confuse our body systems. Statistics show that the incidence of leukemia in children who live under power lines is greater than it is among children who don't. In adults, frequent exposure to high levels of electromagnetic frequencies seems to lower resistance to infection. On the other hand, some people live long lives under power lines and seem to suffer no adverse affects from them.

Electromagnetic frequencies are measured with a gauss meter, named for Carl Freidrich Gauss, the German mathematician and astronomer who defined the unit of energy it registers. Recommendations for favorable levels of electromagnetism are readings of less than three milligauss; readings of over three milligauss are unfavorable. Local electrical power companies have the gauss meters, and will test a site that is a cause for concern. A rule of thumb is to live at least one hundred feet from a transformer and a half-mile from high power lines. Unfortunately, our modern lifestyle surrounds us with multiple sources of electromagnetic fields. The wiring in our homes, everything we plug in, our telephones and beepers, and even our quartz watches are all sources of electromagnetic fields.

Helen and Sam built a lovely home on a hillock in a peach orchard with a beautiful view of the Blue Ridge Mountains. Helen wanted a feng shui consultation because she knew that something about the energy in the house just wasn't right. She told me neither she nor Sam slept well in the house, and they had

☙ Robert O. Becker & Gary Selden, *The Body Electric: Electromagnetism and the Foundation of Life* (New York: Morrow, 1985).

☙ Glen Swartout, *Electromagnetic Pollution Solutions* (Hilo: AERAI Publishing, 1991), p. 7.

both experienced mental problems since they moved in. She had been diagnosed with a degenerative nerve condition that was causing bouts of confusion and problems coping with the simplest tasks. Sam had also changed after the move into the new home; it had become difficult for him to focus on his work and he couldn't complete projects.

The house was a very contemporary, all electric home. All the lighting, temperature, and sound systems were operated by computer. These complicated systems required miles of power and control wiring to feed them electricity and to link them to the computer. I walked through the house, and as I walked into the basement room directly under Helen and Sam's bedroom and looked up, my jaw dropped. The computer and the electrical boxes with all the wires converging into them were mounted up on the wall six feet under the head of Helen and Sam's bed. Not only that, the wires that converged into the electrical boxes were stapled to the floor joists their bed was resting on, so that all of the electricity that flowed into and through the house flowed just under the floor beneath their bed. When they retired at night, believing they were about to receive rest, recuperation, and rejuvenation, their metabolisms were being stressed and confused instead. No wonder their minds were perplexed; the interference to their metabolic processes was enormous. In fact, Helen's nerve disorder mirrored the wiring.

Whether we are contemplating living on a large piece of property or in a home or a small apartment, approach and accessibility are important. How easy or difficult is this place to find and get to? Before I drove to Christine and Ralph's beautiful mountain home, Christine gave me instructions on how to get there. She began with, "Do you have a four-wheel drive vehicle?" The instructions I wrote down covered three-fourths of a page and ended with "Keep on driving up. You'll find us right after you cross the creek the third time." Christine and Ralph are retired and very much

enjoy their mountain retreat; however, special equipment and supplies are demanded by their lifestyle.

How visible is the place? Are obstacles blocking the way? Thomas called me to his home because his massage therapy practice was languishing; his clientele had dropped off soon after he had moved his treatment room into his home. I drove around the block twice before I found his place, and I wasn't sure I was at the correct residence until I knocked on the door and asked. His home and the path leading up to it were completely hidden behind a tall hedge.

What is the road leading to the place like? If we live up a steep driveway, for instance, it will be hard to get home when the roads are icy. An old feng shui adage holds that if our place is above the road it will be hard to get home and if our place is below the road, it will be hard to leave. Before we choose a home, it is worthwhile reflecting on potential obstacles to arriving or departing, for if we have problems with access, good fortune will too.

The last external factor to be discussed is neighborhood influences. General guidelines for favorable neighborhood influences include such ambiguous and unquantifiable qualities as healthful, prosperous, uplifted, and well-favored with good climate and vistas. Certain areas manifest these elusive qualities more than others. Property on the Pacific coast in San Diego County is some of the most expensive property in the US, as is oceanfront property in Hawaii. And in spite of the importance given to the armchair location, certain other spots are also considered especially fortuitous, like the position between the dragon's eyebrows on a dragon formation, a ridge where vibrant earth chi is at the surface.

The list of unfavorable neighborhood influences is more tangible. Churches, where funerals take place, and graveyards are unfavorable because of the grief associated with them. Other unfavorable neighborhood influences include airports, landfills, crack hous-

es, and so forth. Less obvious unfavorable neighborhood influences are shopping malls or grocery stores nearby, which might seem convenient, but are sources of congestion instead. Would we appreciate living near schools, vacant lots, or factories? What buildings are in the vicinity? Would this home be dwarfed or deprived of sun by buildings nearby, or are there buildings in the area with arrowlike corners pointing toward the home? How does the neighborhood look and feel? No one consciously chooses to live near negative neighborhood influences, and it serves us well to study the neighborhood surrounding our potential home using feng shui awareness and understanding.

As we scrupulously consider the external factors in our search for the best place to live, there is an immense amount of information to bear in mind. Everything in the environment has an effect. The following section is included as a shorthand reference and reminder. It is not and cannot be all-inclusive, but will serve as a basic checklist.

BASIC COMPONENTS OF FENG SHUI SITE EVALUATION

Location, orientation, and history of the site:

Favorable: Halfway up a slope; facing south; protected on the north and sides; water in front; previous owners moved on to bigger and better things.

Unfavorable: Wet, low valleys susceptible to flooding, or dry, harsh, windy tops of mountains; north slopes; previous owners suffered unfortunate circumstances while owning site.

Land shape and features around the site:

Favorable: Square or rectangular lot shapes with no missing areas; site free from geopathic lines; a black tortoise shape to the north, a green dragon shape in the east, a red phoenix in the south, and a white

tiger in the west, and a yellow snake at the center; a home site on the back of a dragon formation, especially between the dragon's eyebrows; stable earth, gentle slope; chi close to surface.

Unfavorable: Land or lot shapes with missing bagua areas; home, particularly the bedrooms, located over geopathic lines; home site under or very near rocky outcroppings, cliffs with loose rock, or landscape features that have an overbearing or menacing quality, like a toad about to jump or a crouching predator; unstable earth, steep slopes; chi recessed from surface; landscape features or buildings pointing at site.

Vegetation, bird and animal life:

Favorable: Healthy; non-invasive; a variety; auspicious deer sightings.

Unfavorable: Unhealthy; invasive; absent; aggressive.

Water and road influences:

Favorable: Water in front, curving to the site; calm approach; accessible; integrative.

Unfavorable: Bridge or road pointing at site; on a straight, speedy waterway or road; corners; Y- and T-intersections; cul-de-sacs; dead ends.

Proximity to transformers and power lines:

Favorable: Gauss meter readings of less than three milligauss; at least a half-mile from high-tension power lines; over a hundred feet from transformers.

Unfavorable: Gauss meter readings of more than three milligauss; less than half a mile from high-tension lines; close to transformers or power lines.

Approach and accessibility:

Favorable: Easy; unobstructed; slightly higher than the road.

Unfavorable: Difficult; blocked; very much higher or lower than the road.

Neighborhood influences:

Favorable: Prosperous; healthful and unpolluted; good climate and vistas.
Unfavorable: Churches; graveyards; landfills; airports; crack houses; pollution; any business or activity that regularly brings noise and traffic.

Making a Home: Internal Factors

After we have considered the external factors of a piece of property, we turn our attention to the internal factors. Despite this shift in perspective, the patterns of energy we are working with remain the same, as do the associations for specific environmental constituents. A blocking wall just inside the front door is an obstacle no one consciously wants built into their life at home. Neither do we want to create problems for ourselves by building in long straight paths along which energy speeds. And why live with the potential of conflict at home that arises when rooms have too many doors?

As with the shape of the land, the shape of the building and the rooms inside it are most easily balanced if they are squares or rectangles. Other shapes are usually workable and can be corrected with the solutions feng shui offers, but when a choice is available, simple shapes are preferred. Likewise, a balance of the five elements is favorable, but imbalances can be adjusted. It is wise to consider how much we are willing to invest in the process of bringing balance to a space.

Ann was a writer and landscape painter. When she moved to the mountains, the home that attracted her

and that she purchased had been designed and built by an interior designer unfamiliar with feng shui. It was a square structure, turned on the lot so that the front door opened right at the point of one of the corners. All the rooms inside oriented along the X and were connected by diagonal, tunnel-like corridors that caused her to continually get lost inside her own home during its renovation. She loved the unusual design and layout, which appealed to her creative nature; however, if she had consulted a feng shui practitioner before purchasing, she would have saved herself a great deal of time, energy, and money. This interesting but complicated home required major adjustments to bring it into balance, changes which necessitated a substantial investment of time and money.

Certain shapes are associated with problems. The Chinese knife or cleaver shape with its long cutting edge, for example, is an unfortunate shape—the sharp knife blade can undercut and make difficult any activity in the room. Louisa knew that something was off in her bedroom because she didn't feel relaxed in it, or sleep well. When we discovered that her bedroom was shaped like a Chinese knife, she hung some crystals along the knife edge. Once they were in place, her delight was obvious. She told me enthusiastically, "The crystals made such a difference! The room feels better and I sleep much better in it."

A balance of the elements in our surroundings feels best to us. Roberta loved white and filled her home with it. The walls were white, the fabrics were white, even the furniture was unstained, light wood. She lived in a city in South Carolina where the daily temperatures climbed into the nineties from May to October. When I asked Roberta why she made her home all white, she said the white reminded her of beach sand and coolness. But her home was out of balance because of this, and even though it was air-conditioned, when she and her family were at home they spent most of their time together on the back

the Chinese cleaver

In a room like this, avoid placing a bed or desk in the area corresponding to the knife edge.

porch—looking out on trees and the lawn, resting on colorfully cushioned chairs.

Conditions that unbalance us, like environments overloaded with one element, are best avoided. Having our view split, especially at the entrance, blocks one eye and throws us off balance, a situation that persists the whole time we are in our space. What we see when we first enter our home affects us the whole time we are there. If we walk into our home and encounter the refrigerator first, for example, we will most likely be hungry the whole time we are home.

contrary door

Placement and orientation of the doors of a home—the voice of adults—plays a significant role in our lives. A home with a front door hidden from the street loses opportunity; front and back doors that line up are a major energy drain. A contrary door blocks our view of the room as we enter, causing tension. Arguing doors, like a room and a closet door too close together, bang into each other when they open.

The windows of the home are the voice of the children. If the windows outnumber the doors by more than three to one, the parents may find difficulty in being heard. Dirty or broken windows cloud clarity for all occupants of the space. Windows without any natural views isolate us and have been proven to delay recovery from illness. Living with high levels of noise contributes to stress. Glare off neighboring buildings shining into our windows is negative chi, as is the glare reflecting into our eyes off shiny surfaces in our rooms, which may be caused either by sunlight through the windows or from poorly placed lighting.

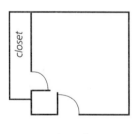

arguing doors

Angled or blocking walls tend to destabilize the nervous system, as do sloping ceilings. Exposed beams in a room weigh down on people who spend time under them. Projecting corners attract and radiate negative energy, pointing at us as we pass. Hallways or small passageways constrict our energy as we walk through them, symbolically placing us back in the birth canal.

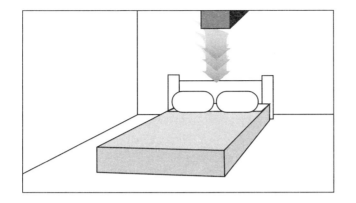

*an exposed beam
weighs down on
whatever is below it*

Stairways present a list of potential difficulties. Do they have risers? Energy falls through the spaces between steps without risers. Are the steps wide enough and are the steps and banisters strong and steady? Does the bottom of the stair point toward the front door, allowing energy to flow out the door? Interesting to look at, but difficult to negotiate, spiral staircases create a vortex, draining energy from a space.

Fireplaces can cause energy leaks—the air goes up and out even when no fire is burning—unless the damper works and glass doors cover the front. Fireplace position in the home or room also presents problems. Good fireplace positions, that is, areas energized by fire, are the fame, family, wealth, and relationship sections of the bagua. Sections of the bagua that conflict with fire are career, helpful people, and children. The knowledge area is a so-so position for a fireplace.

When I was asked to speak to a local group of interior designers, they requested a list of ten things that feng shui says should never be done in interior design. It was simpler to give them a list of solutions, the nine categories of feng shui cures, than to provide lists of what shouldn't be done. Nearly any spatial problem can be adjusted, and the methods for changing the spaces in which we already live are what most of us need to know. But when we use clear feng shui per-

ception to assess a new space before we decide to move in, we have the opportunity to sidestep problems.

The following brief guide for conducting an internal feng shui analysis is included to serve as a checklist.

BASIC COMPONENTS OF FENG SHUI INTERIOR ANALYSIS

Shape and structure of the building:

Favorable: Squares, rectangles, a balance of the five elements.
Unfavorable: Boot, cleaver, L-shape, missing bagua areas, excessive amount of one element.

Approach and entrances:

Favorable: Obvious, unobstructed, well-lighted, path to door at least as wide as door.
Unfavorable: Unclear, more than one, overgrown, dark, unwelcoming, narrow, 90° turns, blocking walls, clutter.

Relationship of doors and windows:

Favorable: Clear, clean, well-placed, unobstructed, well constructed and maintained.
Unfavorable: Contrary doors, arguing doors, too many doors, too many windows, too many paths for chi.

Placement of inner walls, doors, and stairways:

Favorable: Entryway and then conversation room; inviting, welcoming, obvious; stairs with risers, obvious path of daily activity
Unfavorable: Blocking walls, projecting corners, oppressive overhangs, stairs facing door, stairs with no risers, spiral staircases, steep stairs, narrow stairs, unsteady stairs or banisters, arguing doors, restrictions to access, toilet seen from front door.

Condition of the building and fixtures:

Favorable: Sturdy, maintained, working well.
Unfavorable: Broken hardware, missing light bulbs, loose fixtures, dripping facets, broken locks, clutter.

Electromagnetism:

Favorable: Readings of less than three milligauss.
Unfavorable: Readings above three milligauss.

Light and sound:

Favorable: Plenty of good light, absent or low levels of sound.
Unfavorable: Glare, dimness, lights shining into eyes, noise pollution.

Furniture arrangement:

Favorable: commanding position for the bed and desk, relationship to location of fireplaces, stoves, beams, welcoming and comfortable placement.
Unfavorable: Obstruction of pathways, insecure or uncomfortable placement.

Materials and color:

Favorable: Light, clear colors; attractive color combinations; tasteful color choices for intended use of space; pleasing textures and materials; art and decorations reflecting uplifted quality.
Unfavorable: Overwhelming use of dark, muddy, grayed, or somber colors; invasive use of color or materials; use of art or objects with negative associations; sharp or prickly materials; inferior materials, especially in the wealth sector of room, home, lot, or site.

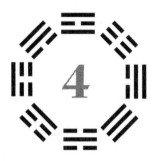

Common Problems of Placement

Learning what to look for and what to avoid in selecting a new space is interdependent with our understanding of chi. In a similar way, our understanding of chi can be applied to the places in which we already live and work. Since we all experience difficulties no matter where we live, learning to detect problems in place design and maintenance gives us an advantage. Many energy depleting conditions are *designed* into our spaces and are therefore troublesome to transcend, while others remain because we fail to recognize their negative impact on our lives. As we develop feng shui awareness, we come to realize the consequences of overlooking or ignoring these common problems of placement. Once we recognize the obstructions to free-flowing energy in our space, we can change and improve our environment with placement art, thus changing and improving our situation.

The following is a breakdown of drastic environmental details that deplete all sections of the bagua simultaneously—a formula for tragedy. These circumstances include energy leaks, imbalances at the main

door, dangerous and overwhelming situations, missing pieces, five-element imbalances, and structural problems. A solution, in most cases only one of many possibilities, comes after each problem.

With **energy leaks**, the money we make escapes as fast as it comes in and we often feel that we will never get ahead. "It's always something," is the rule with energy leaks and drains, because things seem to break so often that resolution never arrives, and things just don't seem right. The ooze of energy loss in this badly out-of-balance situation keeps us behind, exhausts our resources, and poses a clear threat to our financial and physical health. Indicators of energy leaks are:

1. **Front and back doors align:** the energy moves through our place like the bus in the movie *Speed*. **Solution:** a floor-standing screen, or a mobile, wind chime, or crystal directly in the path of the flow usually works. The intention is to divert or deflect the flow in such a way as to encourage the energy to enter all the rooms in the home.

2. **Bathroom or fireplace located in the center of the house:** energy loss is relentless when either a bathroom (drains), or a fireplace (up and away like Mary Poppins) are in the center, the health area. **Solution:** energy loss down bathroom drains is controlled by shutting the bathroom door and placing a mirror on the outside of the door. Energy loss up a chimney stops when the damper and glass doors on the front of the fireplace are closed.

3. **Stairs point out the front door:** even Scarlett O'Hara couldn't prevent the tragedies that befell Tara with its stairs pointing directly out the front door. **Solution:** a crystal or wind chime hung between the base of the stairs and the door will stop this energy drain.

4. **Faucets drip:** this is money literally dripping away.
 Solution: new washers or new faucets, and someone with plumbing skills.

5. **Windows and doors don't work correctly:** do they let air in (and out) even when they are shut? Do they open and close properly, and do they lock?
 Solution: repair immediately. The doors are the voice of the adults in a home and the windows symbolize the children. The vitality of the family unit hangs on this one.

6. **Roof leaks:** it's only a problem when it rains or snows, right?
 Solution: repair immediately. Please do not wait to fix this problem.

7. **Home sits on a mountaintop:** where is the protection and support in this position?
 Solution: trees, hedges, berms, walls, fences or other windbreaks.

Imbalances at our main door prevent opportunity from ever reaching us. That promotion we deserve never manifests; our business doesn't grow; our possibilities seem limited and constricted. In spite of our efforts, things simply do not flow our way. The expression "things just fall into place," never seems to apply to us.

1. **Entrance blocked:** how can energy reach us when our entrance is hidden from the street by trees or hedges?
 Solution: prune and eliminate the blockages.

2. **Narrow path to door:** is the path to the door as wide as the door?
 Solution: widen the path with stepping stones.

3. **Two different doors:** which path will opportunity follow?
 Solution: make clear with signs or other indicators which door is the main one.

4. **Entry below street level, up a long flight of steps, or facing the side rather than the front:** will opportunity bother to notice and get to us?
 Solution: flowering plants in pots and ground lighting guide opportunity to us.

5. **Fixtures, railings, walkway, plantings, and other elements leading to or near our front door in an obvious state of disrepair or decay:** we only get one chance to make a first impression.
 Solution: repair or replace broken fixtures, railings, and walkways. Remove dead or dying plants near the door and replace with silk or healthy plants.

6. **Toilet visible from the front door:** when living with this problem, we never have a chance.
 Solution: keep the door to the bathroom closed and mount a mirror on the outside.

Are **dangerous and overwhelming factors** impacting us in our space? We feel vulnerable and insecure when living with these conditions; disaster seems near and our lives feel out of control. People living with these unfortunate circumstances frequently suffer from divorce, injury, and bankruptcy. Houses impacted by these factors change hands frequently.

1. **Located at end of a cul-de-sac or T-intersection:** too much energy bearing down on us.
 Solution: place a statue or windmill in the front yard between the house and the street pointing at the house. Well-trimmed hedges and trees also help absorb the intense energy aimed at the home.

2. **House too close to front of lot:** we are too available and insecure.
 Solution: a wall, hedge, or fence helps with this problem, but a protective bell should also be placed on the outer doors.

3. **Towering or oppressive neighbor building:** like living next to a bully.
 Solution: a weather vane on the top of our home gives us needed height.

4. **Bed or desk with back to door:** a vulnerable position; how do we know what is coming at us from behind?
 Solution: move the bed and desk into commanding positions.

5. **Oppressive beams over bed, desk, or seating:** quite literally, heavy, heavy hangs over our head.
 Solution: move the furniture out from under the beams.

What pieces of a whole life are we missing? Many home and building shapes create **multiple missing pieces**. One missing piece may be ameliorated; with more than one missing section, equilibrium proves elusive. Living spaces come in all shapes and sizes. To illustrate missing areas, the following shapes have the bagua superimposed on them along with solutions for filling in the missing areas (*see illustrations opposite*).

1. **Cross or wounded dragon shape:** bad luck due to four missing corners.
2. **L-shape:** no matter where the entrance is located, this shape misses out.
3. **H-shape:** all arms and legs.
4. **U-shape:** an empty center.
5. **Boot or cleaver shape:** these shapes must be worked with carefully.

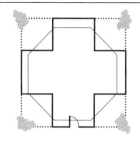

Wounded dragon shape

Plant trees at the missing corners

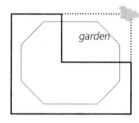

L-shape

Plant a tree or place a statue at the missing corner; make a garden in the missing area

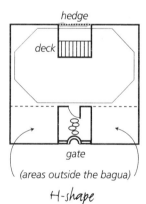

H-shape

Build a gate and fence in front to incorporate missing areas into the bagua; in back, build a deck and plant a hedge.

U-shape

Build deck in missing area and set out planters with yellow and red flowers.

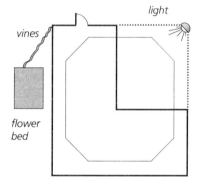

Boot shape

Light completes missing corner; vines and flower bed tip weight of boot away from the toe.

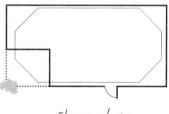

Cleaver shape

Plant a tree at the missing corner. Bedrooms should be located at the rear of the house, away from the knife edge.

Solutions for Multiple Missing Pieces

Are all the elements represented in our space, or do we live in an **imbalance of the five elements**? If we live in a space in which all five elements are not represented, the imbalance created in us persists even when we are in other spaces, and we seek out unbalanced situations because they feel right to us. Viewing the world from this dramatic, but distorted, position prevents clear perception and causes us all kinds of problems.

1. **Building shapes that conflict with their location:** for instance, an A-frame building at the beach, since water controls fire.
 Solution: build a deck around the A-frame supported on round wooden pilings, and with round wooden railing supports. The wood deck buoys and feeds the fiery A-frame that is controlled by the water. The wood deck, fed by the water, transforms the conflict into the creative cycle.

2. **Monochromatic color schemes:** a situation that absorbs the vitality of its dwellers.
 Solution: add other colors.

3. **One interior design material:** the place with plastic wallpaper, plastic flooring, and plastic furnishings, or the place with knotty pine walls, pine flooring, and pine furniture.
 Solution: add other elements.

Many commonly occurring **structural components** in our spaces keep us depleted. Some of these configurations push, poke, or point at us when we are around them, keeping us unsettled. Others demand certain behaviors of us, like the sharply pointed table in the hall that we avoid as we pass so we won't bump into it and get a bruise. Still others, like arguing doors, threaten to harm us as we attempt to use them—our fingers can be caught between them if we are not careful. Then, there is the ceiling that slants our point of view, or the wiring

that keeps us over-stimulated and "wired." We owe it to ourselves to ferret out these problematic configurations and eliminate or pacify them.

1. **Blocked or constricted daily activity paths:** have we arranged our furnishings so that we must step carefully, or pick our way through our space?
 Solution: soften or remove hindrances and create easily traversed meandering paths.

2. **Projections, sharp angles, and knife edges:** anything that points at us delivers deadly, arrowlike chi.
 Solution: place a tall plant in front of projections, or hang a vine down in front of them.

3. **Arguing, contrary, and hidden doors:** our fingers can be hurt by arguing doors, while contrary and hidden doors agitate our energy, robbing us of peace.
 Solution: tie red ribbons around the bases of arguing doorknobs; mirror the wall by contrary doors and draw a figurative arrow to the hidden door with floor mats or wall hangings.

4. **Problematic wiring:** spending too much time near intense or faulty wiring affects body systems.
 Solution: move away from intense wiring and get faulty wiring repaired.

5. **Sleeping under a slanting ceiling:** we rest better in a room with a flat ceiling.
 Solution: if the bed cannot be moved into a room with a flat ceiling, create a flat ceiling in the room, or at least a line across the slanting wall where the normal ceiling would appear.

While other common problems in placement may not deplete the entire bagua, certain issues have a strong negative effect on our lives and must be considered. **Bed placement**, for instance, impacts important and

necessary restorative time. Placing beds in the commanding position in the room, not in line with the door or under windows, and out of daily activity paths offers the greatest support for a good night's sleep. The following factors are best avoided when placing a bed.

1. **Slanted or low ceilings:** the influence on our bodies occurs whether or not our minds acknowledge the effect; we may get a slanted view, or a sense of being oppressed.
 Solution: create a flat ceiling in the room, either literally, or figuratively; lift a low ceiling with torchier floor lamps or wall sconces aimed upward.

2. **Obvious beams:** a ceiling beam running the length of a marriage bed brings marital difficulties, often culminating in divorce. A beam across the foot of the bed can cause foot problems, which, in turn, indicates trouble moving forward in life, since it is the feet that help us move through life.
 Solution: paint dark beams white, hang a crystal at either end.

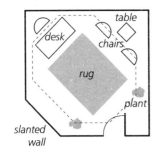

a slanted wall and its remedy

3. **Slanted wall:** destabilizes the nervous system so that we don't rest well.
 Solution: place furniture in such a way that a bagua is created in the room.

4. **Wall with a toilet on the other side or a room under a bathroom:** each time the toilet flushes when you are in bed, some of your attention, and therefore your energy, follows the toilet water.
 Solution: move the bed, or place a small mirror on the side of the bed by the wall or reflecting up on a side table, so that the toilet's noise is deflected.

6. **Next to, or over, a garage:** because of the coming and going of cars, garages are unsettling and polluted.

Solution: stabilize the garage by placing fist- to football-sized rocks in its four corners.

Bedrooms at the back of the home are more secure than those in the front. Current design trends in sub-divisions across the United States frequently place the **master bedroom over the garage at the front of the house**. In many cases, the master bedroom over the garage projects out in front of the main entrance. Such placement presents problems to its occupants.

1. **Not in the home's commanding position:** family dynamics conflict when the parents don't occupy the commanding position.
 Solution: move the parents into the commanding position bedroom.

2. **Above garage:** unsettling and polluted.
 Solution: turn the garage into a study, home office or other room the family uses.

3. **Outside the bagua:** people who occupy rooms outside the bagua lose their connection to the family and spend most of their time somewhere else.
 Solution: use this room as an office or guest room.

If our troubles seem to be focused in only one bagua area and the building shape has no missing area, look for a road, or a projection or knife-edge of a neighboring building that may be aimed at the troubled area. An uneven lot, or one that slopes down in one portion, drains away energy in that area. A commanding position guest room allows guests to dominate, giving them too much power. A house divided into two halves—all the bedrooms on one side and all the communal living spaces on the other—negatively affects the family area. Roads curving away or water flowing away from the house deplete wealth. Blocked doors and windows detract from fame. Relationship

suffers in a home with a split stairway at the entrance. Cluttered horizontal surfaces, like tables, countertops, and desks, stifle creativity. Doors that don't open all the way block helpful people. A garage that blocks a clear view of the street in front of the entrance obstructs career. Knowledge suffers when closets, drawers, and storage areas are stuffed; and a spiral staircase in the center of the house adversely affects health. The list can go on and on.

We have just viewed placement from a landscape of common problematic life situations. When we experience troubles, as everyone does, we can examine our surroundings for environmental aspects that feed and promote our problems. Changing these non–supportive circumstances moves us toward balance and away from a victim's response to suffering. In fact, the energy flows both ways. We learn to live beyond blame with feng shui because we see that we are not powerless victims of our environment: if we are willing to change, we can improve our lives with placement art.

The nine categories of feng shui solutions—simple but powerful tools—are the basic energy adjusters. Once we learn their use, we then turn our attention, in Part III, to holistic applications and success stories, which illustrate the benefits of these solutions.

The Nine Solutions

The Nine Solutions are used to alter, moderate, or raise chi and may be either mundane or transcendent. Mundane solutions seem rational, reasonable, and within the realm of common sense; transcendent solutions seem mystical and may appear irrational and illogical. All solutions incorporate placement and intention. For instance, putting a crystal in place and having it do the work we intend involves hanging the crystal and visualizing what we want it to do. Putting a solution in place is like screwing a light bulb into a fixture; doing the visualization when we place a solution is like flipping the switch that brings the electricity to the light bulb—it brings the juice to the solution.

The nine basic solutions are:

1. **Light**
2. **Sound**
3. **Color**
4. **Living things**
5. **Moving objects**
6. **Heavy objects**

7. Electrically powered objects
8. Bamboo flutes
9. Others

Light. Mirrors, crystal balls, and lighting, the most commonly used bright or light refractive objects, reflect or attract energy, open up space, and give the illusion of expanse. Mirrors, often called the aspirin of feng shui, are used on many levels. In fact, mirrors are recommended so often in feng shui that it is rumored that feng shui practitioners own mirror factories.

We gain opportunities of all kinds by hanging mirrors in our space to augment the natural views that come in our windows or doors. Mirrors may be used to draw in auspicious chi, like a water view. Water represents wealth, so mirroring any water we may have in our view effectively brings that wealth into our space. Mirrors also have a transmitting effect, providing a way through something difficult. When we hang a mirror on a blocking wall just inside our front door, that one mirror can both absorb and send energies at the same time. The mirror absorbs natural views when the front door is open, and provides a symbolic window through the blocking wall we face when we enter, thus allowing chi to penetrate a closed space.

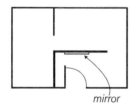

mirror

mirror on blocking wall

Mirrors can also enlarge our perspective and expand an area. Mirroring conference or meeting rooms helps to amplify the perspective and perception of participants. Placing mirrors across from each other in a narrow hall expands the space and clears our minds each time we pass between them. Mirroring small areas we must frequently pass through helps to align or clarify our personal energy and keep us from feeling constricted as we negotiate these narrows.

Mirrors are used to deflect killing chi—the kind of chi received by a home located at the end of a T-junction—or push back energies, like the mirror on the outside of the bathroom door. The powerful bagua mirror, a common fixture on homes in Hong Kong,

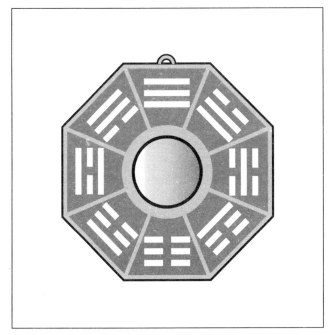

The Bagua Mirror

consists of a round mirror one or two inches in diameter mounted in an octagonal wooden frame that has the bagua painted on it. Placed halfway between the eave or porch roof that is above the front door, this mirror is used to deflect a host of potential negative neighborhood influences.

A word of caution: the bagua mirror must be used with compassion. Amy found this out immediately after she hung up a bagua mirror to keep her neighbor's dogs out of her yard. Amy had repeatedly asked her neighbor to keep his dogs away, but the neighbor was belligerent each time Amy asked him. As Amy hung the mirror, she was visualizing that it would reflect back the negative attitude of the neighbor as it kept his dogs out of her yard. No more than thirty minutes after the mirror was in place, Amy's neighbor made an unsolicited telephone call to Amy to insist that his dogs could go wherever they wanted to. Amy called me immediately to ask me what had gone wrong. After she told me the visualization she had

used as she placed the mirror, my advice was for her to take the mirror down and put it back up while she visualized the mirror deflecting any negativity out into the sky. The advice worked because the dogs stopped coming into Amy's yard and Amy received no more calls from her neighbor.

When Mary put up a bagua mirror it was also for a dog problem. Mary liked gardening, but avoided going into her backyard when her neighbor's dog was out because it would bark and run at the fence each time Mary appeared. Mary hung up a bagua mirror and visualized that the angry dog energy was deflected up into the sky. Thereafter, she could go into her backyard when the neighbor dog was out and the dog no longer barked and ran at the fence. Mary was pleased that she could finally plant and enjoy a garden in her own backyard.

Mirrors don't have to be seen to be effective. People who work in office rooms with many desks in the same room can deflect negativity coming toward them from someone in their vicinity. Carlos said he found it much easier to work after he put a mirror in his desk drawer aimed toward the negative person and visualized that the negativity coming from the other person was deflected into outer space. Carlos said, "The mirror helps clear the air."

A well-placed mirror gives us the security of being able to see who might be coming up behind us if we aren't able to turn our desk or bed so that it faces the door. A feeling of security is also created by placing a mirror behind our kitchen stove to allow the person working at the stove to see what is happening in the room. A mirror on the wall behind our stove doubles our prosperity as well because it doubles the burners where the food is prepared; the food we eat, our nourishment, is wealth. Putting a mirror in our wallet or cash drawer also transcendentally doubles our wealth.

Passing between two mirrors will strengthen thinking and create clarity as will sleeping with a small

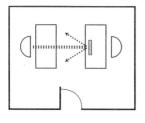

a mirror in a desk drawer can deflect negative energy

round mirror under our pillow at night. Placing a round or oval mirror in the relationship area of the bedroom attracts auspicious chi to our partnership area and creates conjugal bliss. A mirror hung over a fireplace softens and cools this spot of potential volatility.

When we put a mirror in place for a feng shui solution, the following guidelines apply. Use big—the bigger the better—high-quality mirrors placed well, not too high or low. It is especially important to hang the mirror so as not to cut off the top of people's heads—we don't want to give anyone a headache. Mirror tiles are unacceptable because they break up the image and confuse the viewer; clarity is a necessary and significant element of the mirrors we use in feng shui.

Clarity is also a necessary and significant aspect of the crystal balls we use in feng shui. This need for clarity is the reason Austrian multifaceted cut–glass crystals are used rather than the beautiful but imperfect natural crystals. Crystal balls are used to alter or adjust the direction of chi, activate and stimulate energy, and improve the effectiveness of our visualization. Crystal balls reflect sunlight, spiritual and universal light, whether or not they are hung in the light, and like mirrors, need not be seen to be effective. Hanging a crystal ball from the ceiling halfway through a long hallway slows down the speedy energy; hanging a crystal ball from the ceiling where several doors open into a hall or onto a landing slows the energy down and moderates potential conflicts. Hung at the top of stairs, a crystal ball slows energy depletion down the stairs even as it ameliorates our energy as we climb the stairs; hung from the ceiling in the bathroom, a crystal ball brings the energy up, slowing its loss down the drains. Crystal balls hung in windows disintegrate and soften any negative forces coming in windows.

This ability of crystal balls to modify chi gives them many applications. In a situation where the desk or bed doesn't allow a view of the door to the room,

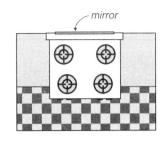

mirror behind
kitchen stove

crystal ball hung
in hallway

hanging a crystal ball from the ceiling halfway between the door and the desk or bed moderates the energies coming in the door. For the modern design that creates a bathroom with no door directly off the master bedroom, energy loss down the bathroom drains can be prevented by hanging a crystal ball halfway between the bed and the entrance to the bathroom; the crystal ball changes the direction of the energy headed down the drains. Crystal balls alleviate the weight of oppressive overhead beams, dispersing other kinds of intense energy as well. The day I hung a large crystal ball in the center of my home to balance the whole space marked the end of the arguments between my two teenage children. Hanging a crystal ball from the center of meeting rooms facilitates discussion and agreement.

Crystal balls, and any other solution hung from the ceiling as a feng shui cure, are hung on a red string or ribbon cut in lengths of nine or its multiples. Our intention goes into the cutting of the red string as we measure it; with nine in mind, cut the string at nine, eighteen, twenty-seven, or any other increment of nine. The color red represents positive power, courageous strength, and auspicious good luck. The number nine is the strongest and therefore most yang number because, as we count, nine is the last number we reach before we start over again. In Chinese culture, nine represents a happy, long life and good fortune. The crystal ball, or other object we are hanging, need not dangle an exact increment of nine; it can hang any length; our thought of nine and therefore, our intention, is directed toward the cutting of the string, not the distance the object hangs down.

Lighting is a basic feng shui solution and, in nearly every case, the brighter the lighting the better. Lighting can open up a space, lift energy, give the illusion of expanse, and enhance any area. A well-placed light can square off a missing corner, or when placed at the low spot, prevent the loss of energy down sloping

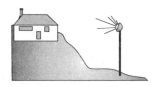

lighting as remedy
for sloping land

land. Wall sconces or torchier lamps serve to lift low ceilings, beams, and other oppressive energy. Lights placed on a steep drive help to slow the energy down. Placing nine lights along the path to our front door guides opportunity to us. Any lights that shine in our eyes, like path lights or floodlights by our front door, create a negative effect for invited guests and should be avoided, except when they are used to frighten away intruders.

torchier to lift low ceiling

Sound. Wind chimes and bells are used many of the same places as crystal balls. A wind chime placed in a long hall moderates and disperses the fast chi flow. A chime hung near our front door calls out a positive message of welcoming; a bell on the door does the same thing, and it provides protection, since the sound of the bell tells us someone is using the door. Wind chimes lift a ceiling or enhance any area in which they are placed. Installing a wind chime or a small crystal ball over our desk creates clarity and creative thinking. Hanging a small wind chime in front of the stove where the cook stands preparing food helps the cook; hanging a wind chime over a conference desk is auspicious and facilitates communication during meetings. Hanging a bell in the fame area of our bedroom improves our reputation; hanging a chime or bell in the relationship area of our bedroom rings in conjugal bliss. A bell on the bedside table of an ill person brings healing energy. Bells or wind chimes need not sound to be effective, and mindfulness in their use, as with all feng shui solutions, dictates that we consider the effect on our neighbors of any solution we put in place.

wind chime over desk

Color. Color, a vital part of any space, provides definition to what exists around us, inspires our emotions, and structures our behavior—we wear different colored clothes for different functions. Each area of the bagua has a corresponding color that we can apply to ourselves and our spaces on many levels. A simple use

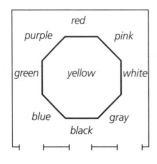

bagua areas and their corresponding colors

of color to balance space is to paint the walls white—white walls create the lightest rooms—and enhance each area of the bagua throughout the space with colored accents.

The water element of the career area is associated with black, which represents money and creates a sense of awe, grandeur, and depth, but painting our bedroom black would make us depressed. The blue knowledge area represents coolness and tranquillity, and for this reason, may not be good for some businesses. On the other hand, green, corresponding to the family area, symbolizes growth, new life, spring, hope, vitality, and freshness; banks often have carpets of green, also the color of money. Green in a family room builds family harmony.

Purple is the color of wealth, richness, financial resources, and high nobility; a purple room is elegant but cool. Red is a very auspicious and powerful color which symbolizes fame, recognition, and justice. But red may also promote violence because of its volatile nature; red cars are involved in automobile accidents more that any other color car. Stop signs are painted red to attract our attention. Tying red ribbons on doorknobs that bang into each other remind people to be careful as they open the doors. Dots of red are often used in feng shui to moderate energy flow.

Pink, a combination of white (the moon, yin energy) and red (the sun, yang energy) is the color of relationships and partnerships; pink symbolizes love, joy, happiness, and romance. White, associated with the children or creativity area, is a blank slate—a perfect state for creation—representing purity, but also condensation and demise. The gray or silver of the helpful people area has a quality of ambiguity, since it may be viewed as a cloudy color or can signify the marriage of the opposites of black and white. Yellow, the official color of the emperor, symbolizes health, longevity, gold, power, and the sun. Brown, orange, and peach are aspects of yellow. Brown, the color of the roots, is often

preferred by older people but has a heavy feeling; orange, a mixture of red and yellow, is auspicious and imbued with happiness and power; peach represents attraction and love, and is considered a good color for single people but not for married ones.

Living things. Living things are used to rectify a design imbalance, lend a sense of peace and harmony to entrances, and bring nature, growth and health into our spaces. Positive thriving plants and floral arrangements attract good things to us and are a sign that things are working well for us. Hedges and trees around our buildings provide a barrier protecting us from negativity aimed toward us. Planting a fruit or nut tree in the wealth area outside enhances our wealth; placing a plant with purple blossoms in the wealth area of our space inside also enhances our wealth. Three or nine plants near a fireplace soften and mitigate the potential volatility fire brings into our spaces.

Plants are used in any area we wish to enhance. Live plants are most favored, but since lighting and other conditions do not always permit them, brightly colored silk plants, and even plastic plants and flowers are used as feng shui solutions and energy enhancers. Unless they are brightly colored, dry plant materials absorb energy and, therefore, are not favored in feng shui. Remove unhealthy plants to reactivate the flow that dies along with the plant. If a plant placed in a wealth area dies, replace it with a larger healthy one. In all cases, keep the materials clean, attractive, and well–cared for.

Bringing aquariums or fishbowls into our spaces adds a perspective of the macrocosm to our lives and creates harmony. Healing and calming when placed near the front door, aquariums are especially beneficial in the offices of doctors and other health–care practitioners. The air the aquarium motor pumps through the water cultivates chi as it bubbles up. The fish swimming through the water, which is a symbol

of prosperity, are appealing and keep the flow moving. Depending on the size of the aquarium or fish bowl, three, six, and especially nine fish are favored.

Moving objects. Like crystal balls and wind chimes, moving objects stimulate circulation and slow down fast energy. A mobile hung over desk or kitchen stove stimulates creative thinking. Flags and windsocks wave to us and bring the energy to our front door. Windmills are effective in keeping chi circulating on deadend streets and cul-de-sacs. A whirligig lifts chi and helps to bring us mail when placed on our mailbox. Weathervanes uplift a roof, handy when a small building is dwarfed by its neighbor.

Fountains, water features, and other forms of hydraulic power bring the water element to us. Inside or outside a business, the motor powering the moving water lifts chi and encourages the wealth to come in. A fountain placed between our home and the piercing, arrowlike road aimed at it disperses the sharp energy.

Heavy objects. Statues and stones are used to balance an odd-shaped corner, or to finish off the missing piece of a room or garden. Stones are used to weigh down the corners of an unbalanced lot; like speed bumps, stones placed with precision along a road slow the energy down. Stones or statues serve as protectors against harsh energy when we place them between us and the energy source. Weighty stones placed in the career area can help us hold down our job; placing a stone or other heavy object in the relationship area helps us hold onto our partner.

Stones are most often applied to areas in need of grounding, like our garages. A current home design places the master bedroom over the garage. Because of the movement of vehicles in and out of the garage, an unsettled feeling is created which translates into one or both of the occupants of the bedroom being gone

a lot. This unsettled feeling is moderated by placing stones in the corners of the garage.

Electrical appliances. Electronic equipment stimulates and moves energy. Even when not turned on, computers and televisions stimulate the flow of ideas. Newer electronic equipment produces far less electromagnetic frequency pollution than older models do, but keeping a safe distance from all equipment is wise. Radiation from microwave ovens, televisions, computers, and sound systems usually dissipates at about eighteen inches from the appliance.

Unspent firecrackers are included in this category of solutions because of the fiery quality of electrically powered objects. Hanging unspent firecrackers in areas we wish to enhance generates chi.

Bamboo flutes. In China's past, announcements of good news were preceded by the playing of a bamboo flute. A popular feng shui cure, bamboo flutes are associated with the positive and lifting message they call out. Bamboo flutes also symbolize peace, safety, and stability because they are long and straight like a protective staff.

bamboo flute

The bamboo plant, a grass, grows with immense life force; left unrestrained, bamboo overtakes other plants and creates a monoculture forest that often covers acres of land. Though hard to the touch, green, growing bamboo is bendable and limber. Each flexible bamboo stalk grows in sections. Each section is perceived as pulling energy up from the earth; and therefore, bamboo flutes are hung with the small end up—the same way bamboo grows.

Bamboo flutes hung up in the corners help lift a room with a low ceiling. Placed diagonally on the side and at the end of oppressive beams, bamboo flutes lift the weight. Hung over the door, a bamboo flute conveys protection. Placing a small bamboo flute between the mattress and box spring of our bed, parallel to the

flutes placed to lift an oppressive beam

way we sleep, supports and strengthens our back. A bamboo flute hung in any area of the bagua strengthens that section.

Others. This last body of feng shui solutions is the largest category and includes anything else we invent to use. To lift the weight of the beam over his bed, Martin used long turkey feathers rather than bamboo flutes or a crystal ball. Sherry softened the corner that projected into her hallway with corner molding from a building supply store. Instead of a mirror, Celeste used hologram paper on the outside of her bathroom door. Stanley sprayed orange scent in his office to elevate his spirits when he had to work late. Pascal hung a photograph of a happy couple in the relationship area of his office to improve his business partnership. In order to enhance wealth in her life, Georgia made an origami fish mobile and hung it in the wealth corner of her dorm room. Daniel put a photograph of himself in the fame area of his home office and landed a profitable contract within the week. Jan put a poster of a breaching whale on the hall wall she faced as she walked out of her bedroom. Emma hung a bird feeder from a tree in the children area of her yard to bring energy to her creative projects.

What we choose to use in solving energy problems is limited only by our creativity and imagination; we are free to use solutions symbolic to us alone. What matters is that the solutions work, and if they don't work, we can always try something else. The first eight categories of solutions are known to work, but are purely suggestions. Play and have fun with feng shui!

Wealth

Part III

Enjoyment

WHAT PLACEMENT ART BRINGS

Tracing the Nine Star Path

By superimposing the bagua on our living spaces, we can focus our attention on the nine aspects of a balanced life, gain the power to clear our spaces of hindrances, and activate a positive flow of chi through them. Tracing the Nine Star Path is one feng shui method for creating this positive change. This practice helps us define ourselves and mark our progress through life as it draws our awareness through the nine points of the bagua in a specific sequence: family, wealth, health, helpful people, children, knowledge, fame, career, and relationship.

The sequence begins with **family**, the source of our values and the seed of who we become. As we contemplate this place of generation, we consider our standing in our family and the nature of our relationships with family members—a family reunion review. What is our place among others? Do we honor our tradition? Where do we fit into it? Have we noticed changes in our relationship with our family since we moved into our space? Since patterns repeat, our family relation-

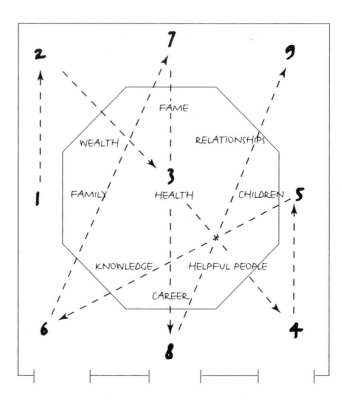

Tracing the
Nine Star Path

ships provide clues to the way we relate with our fellow human beings. Clear and meaningful relationships with family translate into clear and meaningful relationships in life.

Before she died, Kathryn's ailing mother required intensive care from her. The weight of that time for Kathryn was increased by lack of assistance from her immediate family. Hurt by their failure to help, she moved into a new home by herself to begin a new life. Unhappy with the change, Kathryn's family would not visit her new home, a point of sorrow for her. When we walked through her new home together, it quickly became obvious that this residence mirrored the lack of support she felt from her family. An opening to a separate building had been created in the family section of the home during a remodeling of the house

completed before Kathryn moved in, transforming the center of the family area for the whole house into double doors to the outside. Not only that—the living room, dining room, Kathryn's bedroom, and several other rooms in the home all had doorways or windows in their family sections. Kathryn added curtains over doors and windows and placed photographs of her family over the doorways in the family areas of the living room and dining room. Soon afterward, she seemed pleased to report that she was receiving visits from her family.

The demands on Steve and Beth's lives kept them so busy they were not able to spend as much time at home with their young daughter as they wished. During a consultation, we discovered that the family area of their lot and home was problematic. The fence and walkway on that side of the lot was broken and the area had been used to store old boards and junk that needed to be hauled off to the dump. In the family area on the inside of the home on an otherwise blank wall was a fireplace with a broken damper. They cleaned up the outside, repaired the fence and walkway, and planted flowers in the area. Inside, they hung two beautiful paintings of plums with blue and green backgrounds on the wall above the repaired fireplace. Beth recounted to me that "the quality of our family feels much richer, relaxed, and satisfying since making these changes, whereas previously we felt we had little time to be together."

The next area we visit as we trace the Nine Star Path is **wealth**: the blessings of abundance. Abundance takes many forms, and we consider the various manifestations of prosperity in our lives as we contemplate the wealth area. How are things flowing for us in this realm? Are they moving, or do we feel stuck?

After taking my feng shui class, Harry placed a mobile and crystal in the wealth area of his business, "and no kidding, about fifteen minutes later an old

client of mine with an outstanding balance called out of the blue, and proceeded to bring in the several hundred dollar balance."

What is in our wealth area: clutter and junk, or spacious clarity of purpose? David is a musician and his wife Ginny is a producer. During the course of an illustrious career, they had been nominated several times for a Grammy award. They won their first Grammy a few months after we rearranged their office and piles of unattended accumulation were eliminated from the wealth corner.

The wealth area of Paula's apartment was located in a room she used for her office. The previous owners had made the room by enclosing a porch, leaving a six inch drain in the floor. After my visit, Paula covered the drain and put a beautiful Norfolk pine and an angel mobile in that area. She told me that as soon as she made the changes she began to feel better, see more clients, and make more money.

As we continue on the Nine Star Path, the next area we encounter is the center of the bagua, the **health** area. It is impossible to overstate the importance of this area, for we have nothing without our health. The health area offers us stability, security, and an overall sense of well-being. What is in the center of our space and how do we feel when we're there?

When Curtis rented an old building that had been a boxing gym, he thought it would be the perfect space for his growing karate school. But the boxing gym had failed as a business and, unfortunately, Curtis was doomed to failure as well. Within two years, his school closed for lack of students. The center of the old building was located over an underground spring that flowed out from under the back of the building, draining his students and his business.

Nancy called me for a consultation because she and her family, who normally enjoyed good health, were getting ill much more frequently after moving into a

new home. The two-story house had bathrooms at the center of each level. Bathroom drains are vortexes that suck energy down them. Nancy mounted mirrors on the outside of the bathroom doors, which she and her family also began to keep closed, especially at night while they slept. Nancy was delighted that their health quickly improved.

Our next stop on the Nine Star Path is the **helpful people** area, which corresponds to people and situations that benefit us. These beneficial boosts which assist and teach us may come from bosses, underlings, or through travel. Do we have a sense that our efforts are supported and that situations work in our favor at least some of the time?

Sharon's job, just what she had wanted at first, became stifling and stagnant. During a consultation, we realized that the helpful people area was missing from her apartment and, as we discussed her office, it became clear that the same area was missing at work, too. She placed a statue near her front door to complete the missing area at home and placed a beautiful plant in the corresponding section of her office cubicle to fill it out. Three months later she called to tell me she had received a promotion and was moving to Singapore to take a new position in the plant her company was building there. She said she hoped to study feng shui in Singapore and thanked me for helping her get "the job of my dreams."

Toby loved her log home in the mountains, but called me for a consultation because something was wrong with the living room and she couldn't figure out what it was—she just knew she didn't like spending time there. Located in the helpful people area of the home, the living room had a low ceiling formed from enormous dark-stained logs. We discussed changes that included placing a mirror over the massive stone fireplace, with two sconce lights aimed upward on either side of it, removing a wagon-wheel

light fixture from the center of the ceiling, adding torchier lamps that directed light upward at the edges of the room, and adding flowering plants. Toby began making changes even before we finished the consultation by moving a beautiful arrangement of flowers into the helpful people area of the living room, which was also the helpful people area of the house. She called the next day to tell me that several of her weavings, which had been on sale at a local shop for some time, had sold the day of the consultation, and she had received an order for more. She was thrilled!

The **children** area of the bagua, our next stop on the Nine Star Path, includes our offspring and our creative endeavors. Óshé and her husband wanted children, but she had been unsuccessful in getting pregnant. After she studied the bagua in my feng shui class, she placed a large and beautiful plant in her bathroom, the children section of her apartment. The plant grew quickly, outgrowing the room at about the same time she received a positive indication on a pregnancy test kit. The delight in her voice was obvious when she told me, "This feng shui stuff really works!"

After clearing the brush and debris from the children area of his lot, Dennis said his relationship with his stepchildren improved. Barbara's relationship with her stepdaughter, Nancy, improved after she placed six pots of white flowering begonias in the children area of her home. In fact, their relationship improved so much that Nancy asked Barbara to be her backup driver in case she went into labor on a weekday. Barbara described this request by her stepdaughter as "a ground-breaking event."

When we feel frustrated or blocked in our creative life, it's time to investigate the children area of our space. What changes can we make to help get things moving again? The creative excitement was gone from Marvin's job and he found it difficult to go to work

everyday until he cleaned out the closet in the children area of his office. The same day he cleaned the closet, he received a new and exciting project to work on. When he expressed his appreciation for the effectiveness of the cure, there was an obvious, upbeat change in his demeanor and attitude as he told me of this new development.

Tracing the Nine Star Path offers us an excellent opportunity to contemplate the circumstances impacting our life, and our role in maintaining or altering them—after all, we do have choices. The next section we think about is the **knowledge** area, an area that reflects our access to self-improvement, information, and education. This area also corresponds to business savvy and special promotions.

Mary is an example of someone who welcomed change and went through a substantial amount of effort to bring it about. Her hard work resulted in a promotion.

When I went to see Mary, her bedroom was in the knowledge area of her home, and her office was in the wealth area, which in this case was also the commanding position. The commanding position of a home is the room farthest from the front door and is the optimum position for the bedroom of the head of the household. I suggested that it would be better to reverse the activities of the two rooms; that is, to move her bedroom to the back, commanding position of the house and bring the office into the front, knowledge area of her home. As I explained the bagua to Mary, she resisted making the change at first, telling me that it made sense to her to keep the office in the wealth area since her business required very little input from her and was working well. In addition, the office room was painted a deep purple, and if it became her bedroom, Mary said she would not feel comfortable sleeping in a room with such dark walls and would need to paint it.

My purpose in advising her to make the change had two main points. First, Mary's use of the two bedrooms placed her office, and the files for a foundation she described as a volunteer activity she would like to transform into her livelihood, in the commanding position in her home. Mary had put her business and her volunteer work, rather than herself, in control. Second, Mary's volunteer work was with an organization which supported the travel and instruction of a spiritual teacher, a perfect fit for the knowledge area. In addition, placing her business and volunteer activity at the front of the home put them closer to the front door, the mouth of chi. A few months after the consultation, Mary wrote me the following.

> So much has changed! I moved my office into the front bedroom and began the work for the Satsang Foundation in February—and lo and behold, the first of May I was offered a position at the Boulder office—which I took! So I moved out here mid-June after selling most of my belongings and really lightening up. So here I am in a spectacularly new and different environment, working with wonderful people, helping Gangaji do her work—and being paid for it! It's amazing and I feel very blessed. Talk about getting the energy moving...

Sometimes, the change we experience may be much more subtle, but important nonetheless. Julian asked for a consultation because, as he said, "I can't figure out what I should do." A few days after he hung a crystal from the ceiling in the knowledge area of his bedroom, he called to tell me that his confusion had lifted and he was left with a sense of power. The pleasure in his voice was obvious as he said, "It made things simple. My mind got very clear. I am now very directed towards my goal of writing."

The **fame** area of the bagua correlates to our reputation in the community and is the next area we visit as we traverse the Nine Star Path. How are we viewed by those we encounter in the world at large? What is the radius of our influence? Are we in a position to make an impact on society?

Duncan's job as director of the local historical museum demanded much of his time. When he and his wife purchased a modest farm near town, they wanted a place that would allow them a small measure of retreat from the intensity of Duncan's job. But soon after they moved into the farmhouse, which they had not completely finished remodeling, the membership of the museum's board of directors changed, and Duncan's relationship with the board became strained and difficult.

When I visited their farmhouse, they were unclear about how extensively they wanted to remodel their bathroom and had not made any changes in it. After explaining to them that the bathroom, with its vortex drains, was in the fame area of their home, the look of understanding on their faces told me where they would be putting their next remodeling efforts. They painted the woodwork green to help feed the fiery fame element, they hung a red tassel in the window, and they mounted a mirror on the outside of the bathroom door, which they began keeping shut. Within a week, Duncan received a telephone call asking him to appear on a local television program that was doing a segment on the museum, and he was featured in the local newspaper as a community leader. His relationship with the museum board of directors improved dramatically.

The **career** area of the bagua, the next star on the Nine Star Path, represents our journey through life as well as our livelihood. When the career area, corresponding to the water element, is energized, it can mean the

difference in our lives between floating downstream and swimming against the current.

Soon after Marion learned about feng shui, she moved some boxes that had been partially blocking her career area front door, keeping it from opening all the way, and got a wonderful job within the week. She was amazed because she had been looking for a fulfilling and yet flexible job for six months. By moving the boxes, she had literally opened her door to opportunity.

Paulette felt frustrated with her career goals and called me for a feng shui consultation. Several months before the consultation she had submitted a proposal to a local community college to initiate and teach a massage therapy certification program. At the time of her consultation, she had not received any response from the college. When I arrived at her apartment and saw that the entrance in the career area was recessed and creating a missing area, I suggested several options to her. Paulette chose to install floor-to-ceiling mirrors facing each other on the walls inside her door. She liked the fact that the mirrors opposite each other expanded the career area and gave her a sense of clarity as she passed between them when returning home. A week later she received confirmation that her proposal to the local college had been funded by the Board of Regents. Paulette is now the director of the massage therapy certification program at the college.

The Nine Star Path ends at the **relationship** section of the bagua, the area that corresponds to relationships with significant others and business partnerships. When I visited Bill's home, Lynda had just moved out. Bill wasn't pleased with this new development in his life, and didn't understand why it had happened. As we looked around his place together, clues began appearing. One was the dormant compost pile in the relationship area of his yard. Another was the place-

ment of the bed in his bedroom: it was pushed all the way into the relationship corner, leaving no room for anyone to walk around it—anyone who slept on that part of the queen-size bed had to crawl all the way across it and could easily feel trapped there. Bill, a writer and writing teacher, wrote a prose piece about my visit, most of which follows.

> Last night I rearranged my bedroom until twelve midnight with Paul Simon playing "She Moves On" again and again and it wasn't just a random or frustrated rearranging or some spring-cleaning kind of thing but it occurred even though I didn't know I would do it until I did it because a feng shui consultant came to my house and told me... specifically how I had... created a compost pile in the part of the yard having to do with relationship or pushed my bed against the wall and had absolutely nothing in the bedroom in the place of relationship so after tearing every-thing apart and vacuuming old dust and cob-webs from under the bed and feeling that really crazy feeling that happens when you've torn everything apart but not yet put it back together again at 11:30 pm I remembered a beautiful arrow decorated with red yellow green and blue ribbons with a stone arrowhead that a friend gave me for my birthday so I made a small shelf for it right in the place of relationship in my bed-room and went to bed with that arrow erect and the mirror attached to it which was perfect in terms of feng shui because of reflecting the ener-gy just the right way and the ribbons almost flut-tering as if they were outside in the wind or maybe a woman's skirt blowing in the breeze...

When Bill sent me this delightful piece, he enclosed a note with it that said, "Yes... we got back together."

Richard and Johanna moved to beautiful western North Carolina to create their dream of owning and running a vegetarian retreat and bed and breakfast. They found a beautiful large home in a small town, hired a couple to help with the remodeling and to staff the place, and began to remodel. But before they opened for business, the couple they hired had split up and left. Richard and Johanna were left to complete the remodeling and to staff the business themselves, which they did, but not without strain on their relationship. When they called me for a feng shui consultation, they expected to learn some ways to increase their clientele—which they did. In addition, they were surprised to find out that the relationship area of the home was missing and the missing area reflected both the breakup of the couple they had hired when they were starting their business and also the strain Johanna and Richard were feeling within their own relationship. Johanna chose the solution she did because she had already wanted to find a place for a statue of Saint Francis of Assisi. They put the statue at the spot outside that would complete the missing area for the home and planted pink impatiens at the base of the statue. Johanna told me that soon after the statue and flowers were put in place their relationship definitely improved and the atmosphere became calmer and more cooperative, a benefit they had not expected from the consultation, but one they both appreciated.

Tracing the Nine Star Path is a tool for clarifying our intent and style of working with the energy of our lives. We can either walk the Nine Star Path in our minds, or we can actually physically walk it. Some questions worth asking as we make our way along the path are: what does this section of the bagua represent in my life? Is the energy in this area flowing for me, or is it squeezed, blocked, cluttered, stagnant, or absent? Has the quality of energy changed recently; in partic-

ular, has it changed since I moved into this space? How would I like this aspect of my life to flow, and what changes could I make to help the energies circulate? When we follow the Nine Star Path through our environment, we hold a mirror up to our reality. Looking into the mirror with an open mind allows us see what we can do to transform negatives into positives, thus creating blessings in our lives. Small shifts in energies often bring big results.

Attracting Positive Energy

Attracting positive energy is no accident, and can be relatively simple for us to arrange. The same arrangements can be applied to either business or home environments with great success. The place to begin is at the beginning, at the approach and entrance to our space. Since opportunity comes to us through our front door, it is important to assess the impression we make there. What is our curb appeal? How does our front door look from the street in front? Is it obvious? Do we have a sign clearly displayed, or are the address numbers posted near the door and are they clear and easy to read? Are tree branches or bushes blocking the view of the door from the street, or do they constrict the path to the door? Any difficulties in seeing and reaching the door must be eliminated, because an obvious and welcoming front door assists positive energy in reaching us.

A pathway leading from street to door is preferable to a path from driveway to door, but either way, the path should be at least as wide as the door. Painting the door red, or placing something red on or near it

helps attract energy, as do flowering plants near the entrance or along the pathway. A bell or wind chime hung nearby calls out a positive and welcoming sound; a bell hanging on the inside of the door sounds when someone enters—a small but effective security system for those inside. A flag or windsock near the door catches the eye, while moving water outside or just inside the entrance helps to bring in the flow. And, of course, everything should be in good repair and well-maintained—a sure sign of prosperity.

Any ambiguity, like two paths leading to two different doors, must be addressed and clarified. The aim is to create an opening to our world that is welcoming, appealing, and accommodating for ourselves and those we invite in. Alice remodeled her home and added an airlock entry. Unfortunately, the new entrance was set back from the street farther than the original front door, and people continued to try to enter through the old front door. The new front door became the door of choice once Alice put a small sign with an arrow on the old door. The sign asked people to "please" use the new door and pointed the way. After a feng shui consultation, Johanna and Richard changed their entrance to their business by replacing a "No Smoking" sign on the front door with one that said "Thank You for Not Smoking," building a deck with seating, adding lighting, and enlarging the entry. Business increased as soon as the changes were complete.

Japanese teahouses and their gardens provide an excellent example of a welcoming approach. In order to slow down and alter the perspective of visitors, pathways leading to the teahouse are designed with meanders that are rarely flat and make use of stepping stones. This design technique guides the visitor on a metaphorical journey that demands a clear and present mind while it directs the person inward. Once at the teahouse, the guests sit to remove their shoes, don special slippers, and begin preparations for the transforming ritual practice inside, the tea ceremony. A

well-done entry attracts positive opportunity, gives pleasure to arriving, and transports all who pass through; an enticing and well-done entry is the province of an integrating transitional experience between outer and inner worlds.

Besides its function as a passage from the world-at-large to shelter, the entryway also serves as the performance place for the ceremonies of greetings and goodbyes. What does our entryway look and feel like? Is it accommodating and welcoming? Does the front door open all the way, and can we enter unobstructed by furniture or other objects? Obstructions prevent the free flow of energy through our door and pinch our personal chi as we make our way past them. As we walk in, are we presented with a blocking wall, or a wall that splits our view? A mirror may be used to solve this problem; when placed on a blocking wall or a split-view wall, a mirror acts like a window, providing a view through. A mirror near the front door also has the added benefit of drawing in the energy, obvious to us when the door is open and we see the outdoors reflected in the mirror.

Does our entryway bring us in on a landing? Stepping in on a landing is a disorienting and confusing experience because we are immediately faced with a choice of going either up or down. Reaching consensus, and therefore harmony, proves difficult for families living with this arrangement. Solving the ambiguous landing entrance includes pointing the way to the appropriate level with visual clues. Viewing opportunity as a significant and influential visitor dictates that our entrance be obvious, helpful, and hospitable— simple etiquette demands no less. This is especially relevant when we consider that what we do to others, we do to ourselves.

Is the sense of transition to the inside simple and straightforward, or fraught with complicated twists and turns? Susan became critically ill soon after she moved into her new home. Doctors subjected Susan to

a battery of painful and costly tests, but could not determine the cause of her illness. When I first spoke with Susan, she was beginning a slow recovery. As I turned into Susan's driveway for a consultation, I saw that the front door was completely hidden by a large, overgrown weeping cherry tree which I had to skirt around as I walked to the front door. Susan had not noticed the blocking effect of the tree because she always entered her home through a door into the house from the garage. In the garage, as she walked from her car to the door, she walked past garbage and recycling containers and piles of junk that needed sifting through and cleaning out. Once inside, she faced a wall so close to the door that the door would not open all the way and had to sidle left into a dark dead-end space to close the door before she could turn to the right and proceed. The right turn took her past the hot water heater and toward the washer and dryer. Just before she reached the washer and dryer, she turned 180 degrees through a doorway to some narrow stairs that led up to the landing by the front door where she turned another 180 degrees to continue up the stairs, finally reaching the main part of her home. As I explained to Susan that our homes are an extension of our bodies, and that any space we create and occupy plays a vital role in our health and life, she nodded. She told me she was beginning to understand more about the malady that had invaded her than her doctors did, in spite of all the testing they performed on her and the huge bills she paid. It was becoming clear to Susan that every time she entered her home and followed the complicated, obstructed, unwelcoming pathway to the main level, she was damaging her chi, and the end result was this mysterious illness. Before the consultation ended, Susan understood that misreading the environment can have dire consequences, and she began strategizing about leaving the house. Within three months of the consultation, Susan got a great job in another town and moved away.

Adopting an attitude that makes us receptive to positive things brings them to us. We want this flow of energy to find us, enter our place easily, and stay with us so that it can fill our space with its benefits. Do the stairs for the second floor point right out the front door, draining the energy away? Is there a straight line between the front and back doors that channels any energy which comes in immediately out the back? Each of these energy drains is corrected by placing something attractive to the energy, like a simple wind chime or mobile, between the entrance and exit. Chi comes and goes through all the openings in our space, but our entrance—the mouth of chi—is our biggest gate, and its use deserves our special care and attention.

Once inside, the next area we encounter should be a seating place, an area for our guest to rest and to engage in conversation. As a speaker on the art of placement, I am often introduced as "someone who can tell us how moving our sofa will make our lives better." If moving the sofa so that our sitting room is arranged away from a focus on the television and toward an accommodation of the exchange of ideas, then our lives certainly do improve by moving our sofas. Both televisions and fireplaces are energy drains. When the television is on, or when the fireplace is lighted, people in a room will direct their attention to these mesmerizers, which is why focusing the furniture toward them proves absolutely deadly to the circulation of chi. When I said this to Janine during the consultation at her home, her eyes glowed with appreciation. She told me of the wonderful time her family had playing games together by candlelight one evening during a stormy weather power outage. She had forgotten about it until I mentioned the magnetizing effect of the television. Janine called me a week later to tell me she had rearranged the living room and her whole family was enjoying the change. Rather than sitting and watching the television after supper,

they read aloud together in the evenings, to the great delight of the children.

Our conversation place, like any reception room, works best when the chairs orient toward each other and are of a style and material that encourage us to sit comfortably erect. Helpful side tables and appropriate adequate lighting are other critical elements. Once we have attracted the energy to us and provided for its stay, our efforts turn toward using it wisely and beneficially. Respect and care for our environment is crucial.

Everything that has been discussed so far about approach and entryway and comfortable seating arrangement also applies to the feng shui of a business environment. A business prospers when its address is clearly seen from the road, when it has attractive signs, when the pathway to its entrance is unobstructed and enhanced with flowering shrubs or perky paint, when the door opens into a welcoming transitional area, when there is a comfortable reception room for patients or clients, or in the case of a retail business, and when the displays are inviting and well layed-out. Respect and care for our environment is as crucial in our businesses as it is in our homes.

Our home is especially significant to us because we spend half our life there. Even if we work away from home, we spend up to twelve hours a day there—and the majority of that time is spent sleeping. Our home shelters us from the world and our bedroom is the innermost sanctuary of this protection. In many ways, our bedroom is the most important room in our lives because we spend, in theory at least, a third of our time in it, in rest and recuperation. For this reason, our bedroom should be the most balanced room in our home and the placement of our bed of paramount concern to us. Carole moved her bed from a large front bedroom to the much smaller back bedroom of her cottage and noticed the difference immediately. When she told me of the change, she said, "I sleep much bet-

ter back there, just like you said I would." She had moved her bed into the commanding position of her home and her new room.

We sleep better if we place our bed in the secure commanding position of the room—the part of the room farthest from the bedroom door. By simply lifting our head off the bed while we are lying down, we can see anyone who might be coming in the door. Also, the bed needs to have a headboard. If it doesn't, backing the head of the bed against the wall provides additional security. If at all possible, do not place the bed in front of or under a window and leave space on either side. Young children's beds, however, are pushed up against the wall on one side to make them the most secure and comfortable.

Balancing the bedroom is easily accomplished if we superimpose the bagua on the room and consciously place symbols or colors relating to each of the nine areas in the corresponding portions of the room. The items need not be a big deal; they need only to correspond to the area of the bagua they are placed in. For instance, the career area could have our diplomas or certificates relating to our job. We might place our bookshelf and books in the knowledge area, a family photo in the family area. We could hang a mobile, crystal, or wind chime in the wealth area, or we could even frame some money and hang it on the wall there. The fame area would be a good place to hang up a bell or any awards we might have received. In the relationship area, we could place a photo of a happy couple or a plant with pink blossoms, while photos of our children or any objects or materials we use in our creative endeavors could be placed in the children area. The helpful people area could have photos of our personal heros, the pastor of our church, special teachers, or anyone who has been a benefactor to us; placing something silver in that area also works. For health in the center, we might put a yellow or brown rug on the floor. In all cases, we are free to use our imagination

and creativity in applying solutions to balance our space.

During the consultation I did at his apartment, Derrick expressed particular concern about the balance in his bedroom. As we looked around it together, I noticed that many of the objects he had in his bedroom corresponded perfectly with the section of the bagua he had placed them in even though he knew nothing about the bagua before my visit. His diploma was framed in black and on the wall just to the left of the helpful people door to his room. His bookcase and books were in the knowledge area and he had plants under his window in the family and wealth areas. Above his bed in the fame area, a photograph of Derrick wearing his marine uniform and receiving a medal was displayed. As I looked toward the relationship area of the bedroom, I began questioning him about it, because in this corner there was a small table with a saber and some knives on it, along with photographs of a woman and a young boy. He said the woman was his ex-wife and the young boy was his son. He told me his relationship with his ex-wife was strained, and the result of the strain was that the time Derrick was able to spend with his son was far less than he wanted. As soon as I told him the saber and knives were contributing to his problems with his ex-wife, he moved them into his closet. I saw Derrick with his son a week later at a store. He looked pleased as he told me that his relationship with his ex-wife had improved: she was more cooperative, and Derrick was able to spend more time with his son.

Marcie wanted me to look at both the home she was selling and the new one she was about to buy. She had battled cancer in the old, dark home and was anxious to leave it and all the health problems she associated with it behind. The new, bright home symbolized a fresh, healthy life for Marcie. Before she purchased the new home, we consulted together to be certain her new bedroom would be well-balanced. She

agreed to keep the door to the bathroom closed at night and resolved to expand the missing wealth corner of her room. This missing area was a corner projection which stuck out about two feet into the bedroom. Marcie decided to place a mirror on at least one wall of the projection and a tall plant in front of the corner of the projection to soften the point. One other aspect of this new bedroom that might have caused a problem was the sloping ceiling, a destabilizing and unbalanced shape. However, in this case, the walls were painted a clear green while the sloping ceiling was painted white. The meeting of the two colors created a line all the way around the room that gave it the feeling of having a regular top.

bagua colors
applied to a bed

To balance our place of rest even further, we can apply the bagua to our bed; in this case, the foot of the bed is considered the door of the bagua. To balance the bed, simply place something small between the mattress and box spring that corresponds to each area of the bagua—it could be as simple as a small dot of color on a small piece of paper. For enhancing our health, we put a square of yellow fabric between the mattress and box spring in the center of the bed.

When we use our beds as furniture for eating, watching television or reading books, our bodies receive mixed messages about going to bed. Our rest improves if we reserve the use of the bed for rejuvenation only. The television, as with all electronics, is better placed in another room. Electrically heated waterbeds and electric blankets keep our bodies surrounded by confusing electromagnetic frequencies and should also be avoided. Even the electric alarm clocks we put on the night stand by our bed emit large amounts of electromagnetic frequencies and are better placed on a bureau across the room. The sanctity of our personal space is preserved if we can avoid putting our desk and computer in our bedroom.

These days, more and more people are working at home. When we set up an office at home, it is best to

arrange a room solely for this function. If there is no space for a separate office, we should put the office in the sitting or dining room before combining bedroom and office. Unfortunately, space is not always available, and as a last resort we may have to set up our desk in our bedroom.

There are several conflicts that arise when bedroom and office are combined. One is the conflict of functions: sleep and work. When the desk is in the bedroom, we live in the stressful situation of never being away from our work or else being sleepy at work—that bed nearby is such a temptation. A second conflict concerns the commanding position of the room. Which should be placed there—the bed or the desk? We're lucky if the entrance to the room is in the center of the wall, because then each of the opposing corners are commanding position corners; however, if the entrance to the room is near one corner, then only one corner of the opposite wall is a commanding position corner. We actually want both the bed and the desk in the commanding position. The bed needs to be there so we sleep better; the desk needs to be there so that our back is secure and we can look up and see who is coming in the room. With our desk in this position we work better and accomplish more because we aren't worried, even subconsciously, about the possibility of being surprised from behind.

When the bed and desk share a room, preference is given to the placement of the bed. If possible, the desk is also placed in a commanding position; if not, a simple solution is to place a mirror on the wall near the desk so that the entrance is reflected and we know when someone enters the room. The mirror need not be large or expensive. A round mirror, designed to reflect a 180 degree image, like those mounted on automobile side view mirrors, works well.

This small mirror also helps people whose jobs place them at cubicle desks which are bolted to the floor or to wall units and therefore cannot be moved.

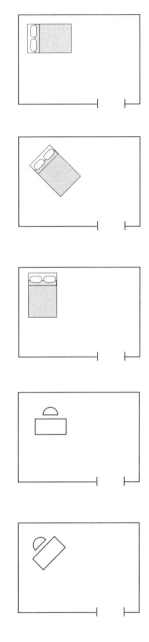

beds & desks in the commanding position

Fred found getting his work done a problem because his cubicle was right next to the photocopy machine. He found he was unable to concentrate because every time someone passed by to use the machine he could not resist the impulse to identify who it was, so he kept turning his head around. He found work easier after he glued a two-inch side view mirror onto the shelf over his computer monitor so that he could glance at it and see who was passing behind him.

Let's look at another common source of energy problems in our spaces—bathrooms. There are usually at least two drains in every bathroom and most bathrooms have three: sink, tub, and toilet. Unless we either keep the drains covered or the door closed, energy from other rooms near the bathroom flows down and out through the bathroom drains continually, even when the water isn't running. For this reason, it is a good idea to keep the toilet seat and lid down when the toilet is not in use. Bathroom doors are best kept closed at all times, but leaving them closed at night is especially important. As added insurance against bathroom energy losses, a door mirror may be mounted on the outside of the bathroom door to reflect the energy, keeping it from entering the bathroom and draining away. The design fad of placing bathrooms adjacent to bedrooms with no door in between is a severe health problem and can be mitigated by hanging an energy attractor—a crystal, mobile, or wind chime—from the ceiling between the bed and the entrance to the bathroom. Another solution would be to hang a curtain between the rooms.

Clutter is another major energy dilemma in our lives. When I was interviewed by the features editor of my local newspaper, she asked me more than once during the course of the interview about clutter, what it means in our spaces, and what causes it. Clutter is stagnant energy: when closets, drawers, and tabletops are full, there is no room for anything else to come in. Clutter is also unfinished business that prevents us

from giving all our attention to the task at hand. My spiritual teacher, Trungpa Rinpoche, would smile as he said that clutter is discursive mind, ever-present chatter and confusion that we may try to ignore, but that manifests outside us nonetheless.

Clutter is also a sign of our speedy society; we have too many things to deal with, and they start piling up around us, visible evidence of the super-fast highway of life on which we live. For many of us, one mechanism for coping with this fast flow is to procrastinate. We feel overwhelmed by excessive demands, activities, possessions, or responsibilities, can't seem to find the time to deal with all of it, and end up literally barricading ourselves in with our stuff. John told me that his feeling of claustrophobia while at home is sometimes overwhelming. "We have too much stuff." he told me. He added, "I don't even label the boxes I put in the attic anymore; I just load them, tape them up, and shove them up there with all the other boxes."

The balance between owning our possessions or being owned by them is a precarious one. Many religious orders have vows relating to owning only the barest essentials, or nothing at all, as a way of dealing with our very human predicament of attachment to stuff. During an interview at her ranch in Abiquiu, New Mexico, the great artist Georgia O'Keeffe was asked about the sparsity of her furnishings. She responded that keeping her environment uncluttered was a constant process; she was ninety-four years old at the time of the interview. Her practice was this: if she wanted to bring something new into her space, she first decided what was there already that had to go—nothing came in without something going out.

Getting our spaces balanced and keeping them so that energy circulates freely doesn't just happen. Balance demands that we pay attention to all the parts of our lives and be willing to adjust. Avant-garde singer Patti Smith met the Dalai Lama at a world peace conference and commented to an interviewer after-

Stephen Foehr, "Death and Rebirth of Patti Smith," *Shambala Sun* (July 1996), p. 35.

ward, "I learned quite a bit from that man... He had to be constantly putting things in balance, constantly adjusting."

Learning to balance our places is a process. If we can deal with one small area of clutter at a time, we begin to feel liberated. For instance, a clutter solution could be as simple as the one my client Kay created: a rectangular table right next to her front door. When she came in her house, she had a place to immediately put her handbag, her keys, her mail, anything she might be bringing into the house. That way she always knew where her bag and keys were and she could come back and relate to what she had brought in at her convenience. Kay's table may seem too obvious a solution to clutter, but it's exactly these kinds of simple solutions that allow us to feel in control of daily existence. Most of us have a natural tendency to let things pile up. Simple solutions like Kay's table circumvent the persistent feeling of being overwhelmed.

There is a handy rule for clutter control, known as the one–third rule, which goes like this: every pile of stuff we accumulate is one-third keepers, one-third archive, and one-third trash. In other words, we keep one third nearby to use, we archive one third for future reference, and one third can go into the round file. After I told this rule of thumb to Patrick and he used it as a reference in dealing with his piles of clutter, he laughed as he exclaimed that he was actually able to let go of far more than one third. The process of letting go is a great energy liberator.

Nine steps help us recognize the energy of place and conclude this chapter. They are offered here as a kind of eye training, a way of guiding us through the process of assessing energy in our own homes or businesses. Whether we are seeking a new living space or looking to improve our current space, keeping the following questions in mind helps us gain feng shui awareness.

A SIMPLE PLACE ENERGY QUIZ

1. What roads or other conduits of intense energy influence this place? Is there water nearby? Is the water flowing or stagnant? What is its orientation: does it flow toward or away from this place?

2. What is your first impression of this place as you approach it? What is the path to the front door like? When entering this place, is there a space like an entryway for transition from outside to inside? What do you see next?

3. In what condition are the locks, doorknobs, plumbing, and fixtures at this place? What kind of lighting is used; what kind of heating is there? What materials are used in its construction?

4. Are the plants around and in this place healthy? Can vegetation be seen outside the windows? Especially important are the views out the main gathering rooms and the kitchen.

5. Are the flow patterns or traffic paths in this place clear and unobstructed? If stairs are present, how are they constructed and what is their orientation?

6. Does the ceiling slope? Are beams exposed and what is the arrangement of the furniture relative to them? Does this place have odd or sharp angles? Are any areas missing?

7. In what position is the desk; the bed?

8. How much unfinished business, uncompleted tasks, or procrastination are obvious in this space?

9. Where is your favorite spot to be in this place?

Questions and Answers

So many of our dilemmas are shared by others, and yet we always feel alone with our struggles. The following questions and answers are real–life exchanges, either shared during consultations or in workshops, or written in reply to letters seeking advice. They are offered here as illustrations of common life situations we all wrestle with as we become more conscious of chi and placement art, both in our homes and at work.

Q: **What's so great about placement art?**

A: A whole lot! With placement art we learn to position ourselves so that we recognize the energies around us. This gives us a clear perception of the way things work, our role in shaping our lives, and the way to improve. We're talking life transforming information here. With placement art, we learn the art of balanced living.

Q: **I have read books on feng shui that use astrology, compass directions, and other mapping tools. Why do you use only the bagua applied from the entrance of the space?**

A: Each of us is the center of our universe; our true home is in the here and now. Since the bagua is a simple centering tool, it is accessible to anyone, and when we focus on creating a balanced life with it, our lives improve in a direct and immediate way. Astrology, the compass, and other tools of feng shui simply expand on this perspective, showing us more about our place within the scheme of things. All these techniques are valid and helpful, but the bagua is the heart of the art.

Q: **How can the bagua, a five-thousand-year-old map, apply to my life today in Tennessee?**

A: Nothing about the bagua conflicts with modern Western lifestyles. The integration it maps has been used to successfully connect people to lives of intelligence and usefulness for a long time—and it still works. For the most part, the Chinese use it on a physical level, to access good fortune. Westerners, disconnected from the natural world by centuries of industrialization, try to connect more with feelings and seek changes on the psychological as well as the physical level. It works either way! Obviously, you are contemplating changes in your life. Use the bagua to give you direction.

Q: **Do modern Chinese use feng shui?**

A: Yes, even though it is officially banned by the government of Communist China as superstition, feng shui is very much alive everywhere the Chinese have immigrated in the East. Hong Kong has been the center of its practice, until recently. Now that feng shui has made it into the West, its secrets are out and we can all use it to our benefit.

Q: **Since my wife brought some feng shui books home, she has rearranged the bedroom and the living room, and she wants to change my office, too. She seems to be**

**moving and changing things constantly. I liked things
the way they were; why can't they stay the same?**

A: We hate change, but change is good—we may as
 well view it that way, since we can't stop it.
 Congratulations to your wife for wanting to make
 both your lives better. I suggest you read your
 wife's feng shui books, and work with her on rear-
 ranging your home and office. As your under-
 standing grows, you will learn to welcome and
 enjoy the changes.

 The process works like this: make the change,
 integrate the feeling, and then move on to the next
 level. You will discover more and more subtlety in
 the energies that surround you, which will neces-
 sitate more and more subtle adjustments to your
 spaces. In fact, just as the work of becoming an
 accomplished person is never done, so too our
 spaces are never finished.

Q: **I recently heard a feng shui consultant being inter-
 viewed on TV. One of the things she said was that the
 environments we live in mirror our lives. Does that
 mean that my house is to blame for the disrespectful
 way my kids treat me?**

A: Is your house to blame for your problems? NO! Is
 it true that your environment and your life's cir-
 cumstances are related? YES! If your kids aren't
 treating you with respect, most likely a change of
 bedrooms is in order.

 I suspect that your bedroom is in the front of
 the house and theirs are in the back, the com-
 manding position of your home. The commanding
 position of any space is the portion of the space
 farthest from the entrance and is the best location
 for the person in charge. This applies to both
 home and work environments.

 Proper relationships in the family demand that
 the parents be in the position of authority, or the
 commanding position. Move your children out of

the authoritative position in your home and put yourself there. The change will make a difference in your relationship with your kids, guaranteed!

Q: **You advise people to put their desk in the commanding position in their offices and as I understand it, the commanding position is in a corner of the room. I think that I would feel trapped if I put my desk in the corner. What's so great about the commanding position?**

A: By placing the desk in the corner farthest from the entrance to the room, your back is secure and protected by walls, you can see anyone coming into the room, you feel in control of the space, and have more energy to devote to your work.

What's great about the commanding position is the authority and security it gives the person who uses it–feeling calm and in control! All CEO's of large companies use the commanding position for their desk. Try the commanding position for your desk, but be sure to give yourself room to maneuver. In fact, the farther out from the wall you are, the more authority you gain.

Q. **What's wrong with sitting with your back to the door?**

A: Over time, you will accumulate stress from sitting with your back to the door. The stress comes from the continued, unconscious fear that somebody could be coming up behind you. This unconscious fear affects your focus and concentration on a day–to–day basis. We have all experienced this lack of focus: we're not completely aligned with ourselves, so we trip on the sidewalk as we walk along, or we lock our keys in our car. These ordinary problems stem from simple furniture placement that keeps us off balance.

Q: **Clutter is one of the biggest problems in my life. I seem to be a clutter magnet! Papers, mail, clothing, dirty dishes all pile up around me, at home and at work. It**

would be a big nuisance, but I'm actually thinking about moving to a new apartment because it will give me a reason to finally get rid of stuff that I don't, or won't, let go of. Can feng shui help me?

A: Sure feng shui can help, and moving is exactly the cure. But you don't have to move to a new apartment—move your awareness and habit patterns instead. By changing your habits, you'll be more in control of your world and you'll feel better. Believe me, this kind of a move is good for your life and worthy of your energy.

You play an active role in allowing that stuff to accumulate around you, and you can play an active role in letting it go and preventing its buildup. Take small steps at first. Write a specific time down on your calendar, and honor your commitment. Aim to spend no more than thirty minutes a day cleaning up, and don't try to clear too much each day. Start with the top of your desk or with the contents of one drawer.

Clearing out the clutter releases stagnant energy and you'll find you begin looking forward to the next time slot you have allocated to freeing up your space.

Then, to keep things free of clutter, devote some time to organizing the flow. Systems help us cope and reduce stress. Decide the best place for things and as you go about your day, pay attention to your actions and don't put things where they don't belong. Procrastination and lack of awareness are the problem—action and attention are the cure. Good Luck!

Q: My relationship with my girlfriend is a big problem in my life. Even though we love each other and live together, we argue about most things, especially money, and there is a lot of tension between us. From the enclosed floor plan of our apartment, can you tell

anything we could change to soften our interactions and reduce the tension between us?

A: Your kitchen is in the relationship area of your apartment. Do you by any chance keep your knives displayed in the relationship area of the kitchen? If so, please move them and watch your relationship soften as the tension releases. Other adjustments that will improve your relationship include placing a mirror on the wall behind the stove so that the cook can see anyone coming in the door behind them. Adding pink in the kitchen will help your relationship also—paint the cabinets pink, put pink canisters on the counter, or paint the walls pink. It these suggestions are too time-consuming or put too much of a dent in your pocketbook, then put pink flowering plants in the kitchen if the light is adequate. If not, get some silk plants with pink flowers to put over the cabinets, or on the counter.

In the relationship area of your bedroom, hang a photograph taken of you together during one of your happy times. Put something in the wealth area of your bedroom that will stimulate that area of your lives, too, such as a bank or jar that you each add your loose change to each day. Putting the bank or jar on a mirror transcendentally doubles its contents. Watching it accumulate is fun and helps you work together on your money issues.

Q: I love the view from my apartment, which I can see as I walk through my front door. My cousin visited me recently and said that it's not good to have a direct line between the front and back of my place, and I suspect she's right. My finances are always a problem—the money seems to go out as fast as it comes in, but I don't want to give up my beautiful view. What should I do?

A: Your cousin and your intuition are right. Your finances are being drained by the alignment of

your front door with the windows in the back. Stopping, or diverting, the fast flow as soon as possible is a must.

To divert the direct flow, add a floor–standing folding screen somewhere between your entrance and the back windows so that you can't see out the back when you walk into your place. While you don't have to give up your view, you won't be able to see the view from your entrance. Then, hang a large round crystal ball over the screen to stop and disperse the rest of the flow. Placing red blooming plants around your back windows will also help you keep and grow your money.

Q: **My place is a wreck. The kitchen faucet leaks, my bedroom doorknob fell off, the light fixture by my front door is hanging down on wires, and many more things in my home need repair. I know these things need to be repaired or replaced, but I can't get them all fixed at once. Where should I begin?**

A: Since you know the importance of having things working well in your home, I won't give you my standard "We're not talking Martha Stewart decoration here, but things need to work" lecture.

As for prioritizing the repairs, call a plumber and get any leaky faucets fixed right away. Then, work on getting your entrance in good shape. Next, focus your attention on your bedroom door and any other problems inside your bedroom. Follow this with kitchen repairs, especially any burners on the stove that don't work. Once the kitchen repairs are complete, turn your attention to any other problems in your home. Keep going and don't give up. Over time, you will transform your wreck into a restoration.

Q: **I heard that good energy is constantly being sucked down the toilet in my home, and that it can make**

me and my family sick. Would you elaborate on this for me?

A: All kinds of energy, good and bad, drains down toilets. Two important factors to consider in determining whether or not your toilet contributes to illness in your family are how near to the bathroom you sleep, and whether or not the bathroom is in the center, the health area, of your home. To be safe, activate this family rule: when not in use, the lid on the toilet stays down—the toilet seat problem is settled once and for all!

Q: I inherited some paintings from my aunt that are dark and somber, much like her. My mother demands that I keep them as family heirlooms, but I want to get rid of them because every time I pass by them I get an unpleasant feeling. What do you say?

A: Let your mother know that you no longer want the paintings because they are too dark for your tastes, and give her the option of taking them. If she doesn't want them, get rid of them. Why surround yourself with things that give you an unpleasant feeling?

Q: How does the bagua apply to the second story of a two-story place?

A: Since the bagua always orients on a space according to the entrance, it superimposes on the second story by considering the entrance to be at the top of the stairs. Stairways come in many configurations. With some, we may arrive at the second floor so that all the rooms are behind us; others put all the rooms to one side of the stairs, while with others we may come up in the middle of the upstairs rooms. If it seems too complicated to apply the bagua to the second floor of your place, simply use the bagua in its strongest application—superimpose it room by room.

Q: **What space is more important to have balanced, home or work?**

A: Where do you spend the most time? They are both very important, but if finances are a priority, start with your bedroom and do your office next.

Q: **Please tell me the best place for a fountain.**

A: Fountains are great for moving the energy. A fountain, or moving water, either outside or inside near the main entrance assists in bringing the energy in, and a fountain in the wealth area helps keep the flow moving. Since the fame area is a fire element, avoid a fountain there. If you live in a place with frequent rainfall, you might not want one at all.

Q: **Why do some places feel especially welcoming and comfortable? I have noticed this feeling once in a while at new places I work—I am a home care nurse. I remember in particular two drastically different homes that each gave me a strong feeling of relaxation and comfort. One was a modest home furnished in the Early American style; the other belonged to a wealthy art collector and was filled with contemporary furnishings and beautiful art objects.**

A: What you felt in the "two drastically different homes" was the owner's positive energy. Because they were mindful and conscious of placing the furniture and art work as they did, the attention, care, and love they used in placing these things radiated from their rooms—what you felt as relaxation and comfort.

A designer's intention and clarity is felt by anyone entering the space. The healthier and more balanced the person designing the space, the better it will be for those experiencing the space.

Q: **I have heard of feng shui consultants asking to be paid in red envelopes, which seems like a bunch of trouble to me. What gives?**

A: The work of the feng shui consultant is considered sacred and powerful. The solutions a consultant gives out are potent and life–transforming. The red envelope honors the solution–giver and the solution, as well as strengthening the results. To pay your feng shui consultant in red envelopes is a small thing with big ramifications. Given that good feng shui equals good fortune, isn't it worth the trouble of buying or making red envelopes?

Q: **What does feng shui have to say about the time of day you look at a site or space?**

A: The time of day a site or space is viewed makes a difference in your experience of it, and when you are pondering a new place, seeing it at different times of day gives you more information about it. For instance, if you are looking at potential new office space, you would want to see it and the area nearby at peak traffic times; and if your business requires you to occasionally work late in the evening, you would benefit from knowing what the area is like at that time of day.

Many feng shui practitioners prefer to visit a space for a consultation during the peak energy phase of the day, eleven a.m. to one p.m. Before building on a property, I recommend that the owners wait a year, so they can see the site at all times of the day and through a full cycle of the seasons. Many problems can be avoided this way.

Q: **I just moved into a new home in a new subdivision, and I want to start off right. What should I do?**

A: Have a feng shui consultant come to your home to advise you about its energy patterns and help you arrange the best placing for your furnishings. Be sure to have your consultant perform a clearing ritual to remove energies left behind by the workers who built your new home, and to welcome blessings to your new life there.

Feng Shui Rituals

Ritual is a significant part of the practice of placement art. Defined as a symbolic act or series of acts, ritual unites vision and practicality—heaven and earth—and provides a way to relate with things properly, for their own sake. Rituals tame existing energies and set the boundaries for the transformation we want to take place. The purpose of ritual is to create a certain frame of mind, and the essential ingredient of ritual is the mental attitude of the participant.

As we perform feng shui rituals, we join the wisdom of ancient traditions—insights kept alive and passed down through time—with the realities of contemporary life. We are welcome to apply them as they have come to us or to modify and adapt them to our own religious or spiritual beliefs. One of the goals of feng shui ritual practice is to aid us in defining and clarifying our intention. When our intentions are clear—pure energy shining forth unobstructed—well-being and success are stimulated.

Intention Activation Technique. Each time we make a change or place an object for a feng shui purpose, the change or placement is activated and empowered by performing the Intention Activation Technique, a ritual that focuses the energies. This technique synchronizes us—our body, speech, and mind, the whole person—with the change we are making in the environment. Perform the three-part Intention Activation Technique as soon as the object is in place. If, for some reason, the technique isn't performed immediately, do it within three days of making the feng shui change.

The three components of the Intention Activation Technique are a mudra, mantra, and a visualization. A mudra is a hand gesture. We use mudras often in the course of our day; for instance, each time we wave at someone, we are performing a mudra. The mudra is the body component of the technique. The speech component is a mantra, words or syllables that express the quintessence of various energies. "Hello!" is a mantra, as are the vowels a, e, i, o, and u when spoken. The third component of the Intention Activation Technique, the mind component, is a visualization. Visualization is the use of positive, affirming, mental pictures to obtain goals, and is widely used in the creative arts, sports, business, religious practice, and in personal self-improvement.

To perform the Intention Activation Technique, we stand near the new change or feng shui object, arrange our hands in a mudra, recite a mantra nine times, and then create the visualization in our minds. The mudra can be the Praying Hands mudra, the Heart and Mind Calming mudra, the Expelling mudra, the Blessing mudra, or any other mudra from our religious or spiritual tradition (*see next page*). The mantra, repeated **nine** times, may be the Heart and Mind Calming mantra (*Om gaté, gaté, paragaté, parasamgaté, Bodhi, svaha!*); the Six True Words mantra (*Om mani padme hum*); or any other mantra from our own spiritual background, like The

*heart and mind
calming mudra*

expelling mudra

ཨོཾ་མ་ཎི་པདྨེ་ཧཱུྃ

om mani pad me hum

Intention Activation Technique

Body: a mudra or ritual hand gesture

Heart and Mind Calming mudra

Expelling mudra

Blessing mudra

Praying Hands mudra

Mudra from your own spiritual tradition

Speech: a mantra or prayer recited **nine** times

Heart and Mind Calming mantra: Om gaté, gaté, paragaté, parasamgaté, Bodhi, svaha!

Six True Words: Om mani padme hum

Other mantra: The Lord's Prayer, Hail Mary, Go with God, or a mantra from your spiritual tradition

Mind: the visualization

Imagine a story that has the following elements:

beginning—why you are putting the feng shui solution in place

middle—in which the solution is doing the work you intended

end—in which the solution is working and the energy has been adjusted for positive effect.

Lord's Prayer, Hail Mary, or Go with God. The visualization is a short story or movie played in our minds, during which we imagine as clearly and realistically as possible what we want to happen as if it is already happening. Our visualization will have a beginning, a middle, and an end. The beginning of our visualization shows the reason we are putting the solution in place, and gives us an opportunity to acknowledge our existing situation or a core negative belief that is blocking change. The middle of our visualization shows the solution producing the desired effect now. The end of our visualization shows that the need for placing the solution is continually and completely altered; things are different because we have created something new, and now we watch for the change. The solution and the ritual prompt the change; the change itself is fruition. The more detail we visualize, the greater the effect the feng shui solution brings.

Let's use a powerful bagua mirror we have just hung up over our front door as an example. We have hung the mirror to deflect particular energy in our outside environment. In this case, our place is located near a cemetery. Once the mirror is hung, we stand under it, hold our mudra and say our mantra nine times. Then we take a minute to visualize. The first part of our visualization acknowledges that we live near a cemetery and that the sadness emanating from the cemetery affects our daily life. After picturing the situation as it is, we move to the middle part of our visualization, where we see the grief being deflected into space by the mirror. The third, and final part of our visualization shows us released from any negative cemetery energy and shows our place as impervious to any further cemetery influences. In essence, with this three step visualization we have befriended the situation by acknowledging it, cleared the obstruction, and redefined our space. This three step flow applies to every visualization we do when we put a solution in place. We can use this visualization technique as

often as we wish throughout our day; we don't need to have put a solution in place to use this ritual to shift energy. We can even use it first thing in the morning, sitting on the edge of the bed before our feet even hit the floor, seeing a good day for ourselves. Performing the entire Intention Activation Technique ritual takes only thirty seconds to a minute to complete. It takes far less time to do than it takes to explain, and doing it is much more effective than reading or talking about it.

The Red Envelope Tradition. The Red Envelope Tradition is a long-standing Chinese folk custom used in gift-giving; children, in particular, receive red envelopes with money in them on many occasions. The color red—a strong tool for overcoming negativity—symbolizes positive power, courage, strength, and auspicious good fortune. In addition, the rectangular shape of the red envelope resembles an ancient shield—a tool used for protection. In feng shui practice, the Red Envelope Tradition is used to demonstrate appreciation and awareness as well as to protect the feng shui practitioner.

When we receive feng shui solutions from anyone, including our loved ones, we give them a red envelope with some amount of money inside. When we give feng shui solutions to anyone, including our loved ones, we receive a red envelope with some amount of money inside—the amount depends on the giver's financial means or is a set amount agreed upon ahead of time. Money, rather than mementos or anything else, is used in the red envelope because money symbolizes completion. The red envelope ritual honors and protects the powerful wisdom that is exchanged, and serves three additional purposes: 1) the sincere intention and respect of the person receiving the solution is expressed by the act of procuring or making the red envelope, placing money inside, and giving it to the solution-giver; 2) the solution-giver is protected

from losing personal energy; and 3) the effectiveness of the solution is increased.

In general, one red envelope is offered for each solution received. In the case of a consultation in which many solutions are transmitted, the number of red envelopes exchanged is either nine or increments of nine; some consultants receive as many as one hundred eight red envelopes for their services. When we receive a red envelope we sleep with it under our pillow before we open it. Prior to sleeping, we use the Intention Activation Technique to visualize that the information we have shared will provide the strongest positive effect and that any negativity released as a result of the feng shui solution will be deflected into space.

Although red envelopes may at first seem like an unnecessary formality, they do have power of their own, as shown by the following story. Lynda received a red envelope at the end of her visit to the Lin Yun Temple on Long Island. Feng shui was new to her, and the only reason she had gone to the Temple was as a favor for her friend who was a feng shui consultant. Mystified by the red envelope, she asked, "What should I do with it?"

"Put it in the wealth area of your bedroom," her friend replied. The next day, when Lynda went to traffic court to attempt to get an old parking ticket fee reduced, she was told that the policeman who had issued the ticket had failed to enter the date on it, which automatically dismissed the fine, to Lynda's great delight. When she told her feng shui friend about not having to pay the fine she said, "I'm reaping benefits from the red envelope already...I must go buy a lottery ticket."

Tracing the Nine Star Path. Tracing the Nine Star Path clears a space of old, depleted, and negative energies, making room for new, uplifted, and positive ones to enter. This change of energies is accomplished by

drawing our personal energy through the nine points of the bagua in the sequence described in Chapter 6 of this book. The sequence of the nine points of the bagua we use in performing this ritual is: 1) family, 2) wealth, 3) health, 4) helpful people, 5) children, 6) knowledge, 7) fame, 8) career, and 9) relationship.

We begin the Tracing the Nine Star Path ritual with the Intention Activation Technique, holding the Heart and Mind Calming mudra while we repeat the Heart and Mind Calming mantra nine times. During the visualization component of the ritual, we project blessings to each of the nine points as we visit them, either by walking through the house and touching the Nine Stars in sequence or by discussing our lives in relationship to the nine points with a feng shui practitioner.

Space Clearing. Many cultures regularly perform space clearing rituals. In most Western cultures, it is common for construction to be initiated at the site of a new building project with a ceremony that includes digging the first shovel of dirt; once the building is complete, ribbon–cutting ceremonies are performed. In Hawaii when a new building is begun, an eclectic clearing ceremony is performed, incorporating Christian, Buddhist, and native Hawaiian elements. Tibetan Buddhists perform a clearing ceremony called a Lhasang to set the tone for special occasions. Space clearing may be as simple as burning incense to clear the air, or as complex and time–consuming as a total spring cleaning. New Year's celebrations are clearing rituals that chase away lingering energies from the old year and hasten the arrival of new energies; during Chinese New Year celebrations, many firecrackers are exploded to facilitate this change.

Space clearing rituals serve the purpose of allowing us to let go of constricting beliefs and patterns and replace them with positive, supportive ones. Although we may believe that negativity will go away if we

ignore it, the reverse is actually true. In fact, the more we ignore negative energies, the stronger they become. Acknowledging existing energies gives us a platform for placating and adjusting them to make room for new, supportive, and more productive ones.

When we move into a new space, clearing out old energies creates a good beginning. One simple space clearing ritual is to place the peels from nine citrus fruit in a bowl with water, then sprinkle the water lightly everywhere in the new place, making sure some citrus water is sprinkled in the closets and cabinets as well. Once the entire place has been sprinkled, pour a small amount of the citrus water down each of the drains. Performing the Expelling mudra, chanting the Six True Words, and visualizing any lingering negativity being released and floating out the windows and doors makes this simple ritual highly effective. Another feng shui ritual that encourages new growth is the Yu Wai blessing ceremony. It is performed in much the same way as the citrus–water ritual, except with the Yu Wai blessing ceremony, rather than water, rice or any other kind of seed is sprinkled around the inner and outer walls of the space; seeds symbolize new growth.

Betsy wanted a feng shui consultation because of the ghosts that followed her around her house. Even though she recognized them as the spirits of her dead relatives, their presence in her home made Betsy distraught. We performed clearing ceremonies for the inside and the outside of her home. A week after we cleared the energies, Betsy called me with the good news that the clearings worked beautifully. The ghosts had left the day we did the clearings, and during the week after the clearings, her husband received a big promotion and pay raise at work.

When I visited Mary Jane, I noticed a small side table in her dining room with objects representing the elements carefully arranged on it: a natural quartz

crystal surrounded by a small bowl of water, a wooden whistle, a candle, and a silver dollar. I asked Mary Jane the purpose of this arrangement. She said it represented balance to her, and that the ritual she performed daily with the arrangement served as an energy clearing.

Each evening Mary Jane stands in front of the arrangement and performs the Intention Activation Technique, using the Heart and Mind Calming mudra and mantra. She then carries the bowl of water into the bathroom with her left hand—she is right-handed—and empties the bowl into the toilet, rinses the bowl three times in the sink, and refills it. As she performs the ritual, she visualizes that she is flushing away all negative energies down the toilet, and that she is overcoming her weakness, which is why she uses her weaker hand (the left, in her case).

Another personal space clearing and protection ritual is performed by reciting the following sequence of the Six True Words eighteen times:

Om Ma Ni Pad Me Hum
Hum Om Ma Ni Pa Me
Me Hum Om Ma Ni Pad
Pad Me Hum Om Ma Ni
Ma Ni Pad Me Hum Om

Maintaining fresh flower arrangements in our space helps keep it clear. Citrus scent uplifts the energy in a space, and fresh citrus peel—before it has dried out—refreshes room energy. Wearing citrus scent, highly recommended for health-care practitioners, protects us from absorbing negative energies in any environment. Always buy a new broom for any new space to avoid bringing old dirt into the new place; when moving into a new home, buying new sheets for the beds facilitates a fresh start.

Cultivating Intuition

Intuition is our direct link to the life force that flows everywhere around us. Since the 1970s, intuition has been increasingly acknowledged and applied to a wide range of business, scientific, and health care endeavors. Intuition, a right brain function, is a clear and direct knowing that comes without explanation as to how or why. We all have intuition; it is especially active in us as children and adolescents, but tends to be repressed as we grow into adults.

There are many ways to develop our latent intuitive abilities. Throwing the *I Ching*, contemplating Biblical scriptures, saluting the east or Mecca, meditating, spending time in natural settings, performing martial arts, writing, painting, performing and listening to music, doing the tarot, and cooking are just some of the activities known to enhance intuition. What strengthens our intuition the most is using it. The ability to discriminate environmental energies, which is the essence of the practice of feng shui, depends a great deal on the cultivation of intuition. When we ignore our intuition and fail to acknowledge energy, we feel cut off from our surroundings and are literally divorced from sources of vitality.

Place Awareness. A simple method of strengthening our intuition is the practice of Place Awareness. With this exercise, we develop an understanding of the way intuition works because we pay attention to our feelings rather than our minds, and we honor our innate reactions. It can be practiced at the grocery store, at the museum, at work, at a friend's house, or anywhere you go. It works like this:

1. Decide ahead of time that you are going to practice Place Awareness in the next place you visit.

2. Before entering the place, perform the Intention Activation Technique to clear your mind.
3. Walk into the place and feel the sensations that arise. What are you feeling? Where in your body are you feeling it? What in the surroundings speaks to you? What draws your attention? Simply notice what arises for you in this place.
4. Attempt to connect the sensations you feel with elements in the immediate surroundings. *Note them with interest and without opinion.* Are you cold in the supermarket? Do you feel exposed having coffee because you chose a table directly under a strong light? Do the stairs that point at you as you walk into your friend's house make you feel unwelcome? When you enter the Chinese restaurant do you immediately relax because of the beautiful, large aquarium in the foyer? Does your office make you feel anxious or creative?
5. For further practice and to sharpen your skills of observation, keep a journal of your place energy experiences and discoveries.

Afterword

Maintaining the Connection

Once we read about placement art and begin to incorporate it into our minds and spaces, it begins to flow through our lives with an energy of its own. This book, written with the intention of making feng shui available and accessible to everyone, is a beginner's guide. We may wish to study further or make a personal connection with a feng shui consultant or teacher. Due to the current organic explosion of interest in feng shui, many opportunities exist for connection. Two resources for expanding our inspiration and wisdom are the Yun Lin Temple at 2959 Russell Street, Berkeley CA 94705 USA, tel (510) 841-2347; or *Feng Shui Journal* at P.O. Box 6689, San Diego CA 92166 USA, tel (800) 399-1599.

Placement art is a long-term project; we are always cultivating our intuition and place awareness. Please keep in mind that feng shui is a tool we may use as superficially or deeply as we wish. We are free to study, learn, discover, and experiment with this art of placement. What we find as we invest our time and effort in understanding the energies of our world is that with

common sense and intuition as our guides, we can modify our surroundings to create an unobstructed, gentle flow of vital energy through them. This flow brings us balance and well–being.

In most cases, feng shui solutions are simple and inexpensive. Please note, when putting solutions in place, it is best not to discuss them until after they work; talking about the solutions we are doing dilutes their effectiveness. After they have worked, we may share them, as long as we honor the Red Envelope Tradition.

For good fortune, here are some simple tips on ways to refresh energy and maintain your connection to place.

1. Carry money in your pockets the first day of the new year so that you will have money all year.

2. Create and perform a ritual cleansing of your home the first day of the year to symbolically clear out any lingering old problematic situations with their associated negative feelings and to make room for new positive situations and opportunities.

3. Celebrate the ending of the old and welcome the beginning of the new by having a party with family and friends that includes food. A potluck is especially auspicious for a celebration at this time.

4. Wish people a Healthy and Prosperous New Year instead of wishing them a Happy New Year.

5. Enter your home only through the front door for the first nine days of the new year, and if you find that it is not obvious, unobstructed, well–lighted, and welcoming, change it. Opportunity, like a special guest, comes to you through your front door. Make your special guest welcome.

6. Rearrange your bed to improve your sleep by: a. moving the head of the bed against a solid wall, b. making sure that you can see the entrance to the room from this position, and c. checking to be sure that the foot of the bed is not in direct alignment with the entrance to the room.

7. Keep the toilet lid down when not in use to prevent good things from going down the toilet. Anyone with a toddler at home is familiar with this practice. If your bathroom is directly off your bedroom, sleep with the bathroom door closed to keep your good energy from going down the bathroom drains while you sleep.

8. Run your fingers through your hair from the front to the back ninety-nine times when you first get up in the morning for the first nine days of the new year, or any time. This practice offers relief from headache, lowers blood pressure, improves one's vision, and contributes to long life.

9. Follow a popular Chinese folk custom and place monies in red envelopes when gifting money and to pay for appreciated services. The red envelopes are believed to bring good fortune to both the giver and the receiver.

May *Placement Art* be of benefit.

Based in western North Carolina, Penelope Anne Lindsay consults and teaches feng shui. She may be reached at:

> 375 Dula Springs Road
> Weaverville, NC 28787
> e-mail: PlaceArt@aol.com
> tel/fax: (828) 645-1071

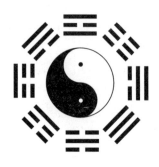

For Further Study

Arguelles, José, and Miriam Arguelles. *Mandala.*
Berkeley: Shambhala, 1972.

Bacon, Edmund N. *Design of Cities.*
New York: Penguin, 1974.

Becker, Robert O. and Gary Selden. *The Body Electric:
Electromagnetism and the Foundation of Life.*
New York: Morrow, 1985.

Bird, Christopher. *The Divining Hand.*
Black Mountain: New Age Press, 1985.

Campbell, Joseph. *Historical Atlas of World Mythology.*
New York: Harper & Row, 1988.

Campbell, Joseph. *The Masks of God: Oriental Mythology.*
New York: Penguin, 1962.

Chödrön, Pema. *The Wisdom of No Escape*
Boston: Shambhala, 1991.

Foehr, Stephen. "Death and the Rebirth of Patti Smith."
Shambhala Sun, July 1996.

Gallagher, Winifred. *The Power of Place.*
New York: Simon & Schuster, 1993.

Gawain, Shakti. *The Creative Visualization Workbook.*
Mill Valley: Whatever, 1982.

Guiley, Rosemary E. *Harper's Encyclopedia of Mystical &
Paranormal Experience.*
San Francisco: Harper, 1991.

Huang, Chungliang Al. *Quantum Soup.*
Berkeley: Celestial Arts, 1991.

Lip, Evelyn. *Feng Shui: Environments of Power.*
London: Academy, 1995.

Myss, Caroline. *Energy Anatomy.*
Boulder: Sounds True Audio, 1996.

Ni, Hua–Ching. *The Book of Changes and the Unchanging
Truth.*
Santa Monica: Seven Star Communications, 1994.

Pennick, Nigel. *The Ancient Science of Geomancy.*
Sebastopol: CRCS Publications, 1979.

Rossbach, Sarah. *Feng Shui: The Chinese Art of Placement.*
New York: Arkana, 1983.

Rossbach, Sarah. *Interior Design with Feng Shui.*
New York: Arkana, 1987.

Rossbach, Sarah and Master Lin Yun. *Living Color.*
New York: Kodansha, 1994.

Schwenk, Theodor. *Sensitive Chaos.*
New York: Schocken, 1976.

Steinem, Gloria. *Revolution from Within.*
Boston: Little, Brown and Company, 1992.

Swan, James A., ed. *The Power of Place.*
Wheaton: Quest Books, 1991.

Swartwout, Glen. *Electromagnetic Pollution Solutions.*
Hilo: AERAI Publishing, 1991.

Too, Lillian. *The Complete Illustrated Guide to Feng Shui.*
Shaftesbury: Element Books, 1996.

Trungpa, Chögyam. *Shambhala: The Sacred Path of the Warrior.*
Boston: Shambhala, 1984.

Tu, Lynn Ho. "Questions & Answers."
Yun Lin Temple News, December 1994.

Venolia, Carol. *Healing Environments.*
Berkeley: Celestial Arts, 1988.

Walker, Barbara. *The Woman's Dictionary of Symbols & Sacred Objects.*
San Francisco: Harper, 1988.

Wilhelm, Richard. *The I Ching or Book of Changes.*
Princeton: Princeton University Press, 1967.

Wing, R. L. *The Illustrated I Ching.*
Garden City: Dolphin/Doubleday, 1982.

Xenja, Seann. *Feng Shui for Practitioners.*
Yountville: International Placement & Design Resources, 1995.

Xenja, Seann. *Introduction to Feng Shui.*
Videocassette. Carson: Hay House, 1995.

Xenja, Seann. *Advanced Feng Shui for Home and Office.*
Videocassette. Carson: Hay House, 1996.